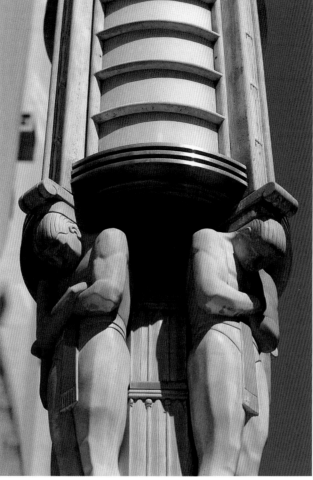

NEW YORK
DECO

NEW Y

DEC

YORK

CO

PHOTOGRAPHS BY
RICHARD BERENHOLTZ

INTRODUCTION BY
CAROL WILLIS

SCRIPTUM EDITIONS

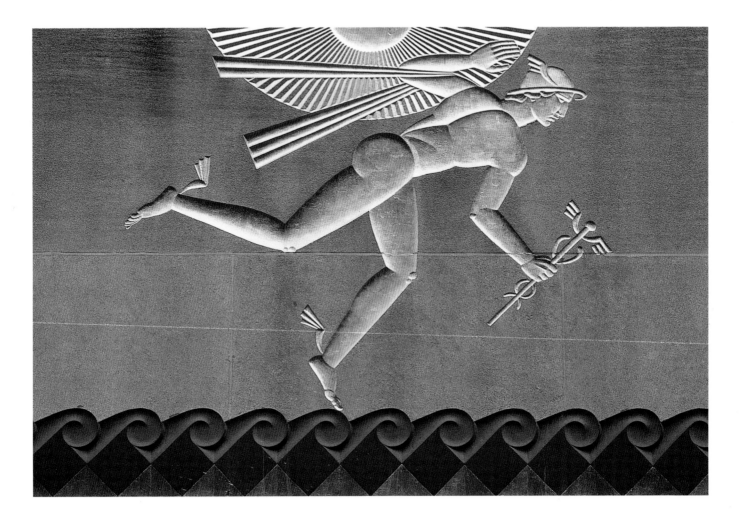

PAGE 1: Charles B. Meyers built the New York Department of Health Building at 125 Worth Street in 1936. For the two entrances, there was extensive metalwork done by Oscar Bach. Along with medallions on the themes of health and sanitation, Bach created a large, modern-looking eagle and this lantern with telamones.

ABOVE: A stunning mosaic from the original 1930 International Telephone and Telegraph Building on Broad Street. The building was designed by Louis S. Weeks.

FOR MY SON JACK — R.B.

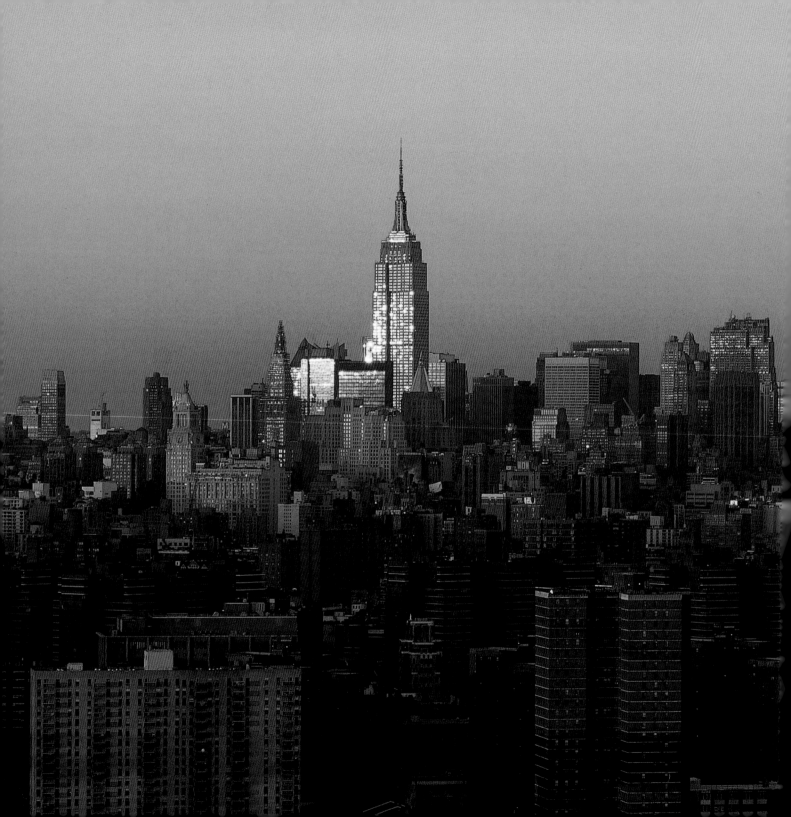

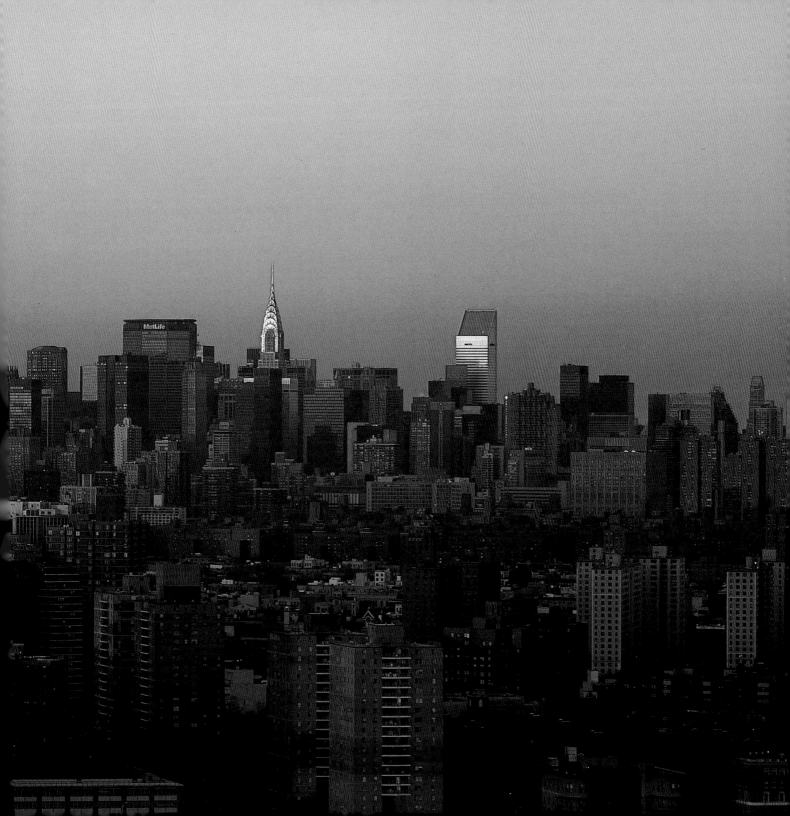

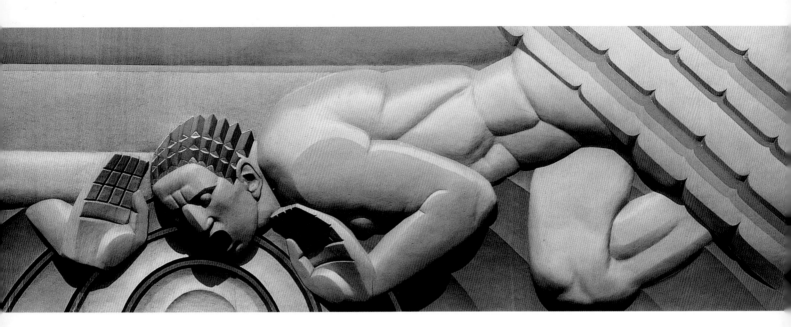

INTRODUCTION BY CAROL WILLIS

NEW YORK IS AN ART DECO CITY—indeed, *the* Deco city—as Richard Berenholtz shows us in his opulent photographs. Its Deco identity is projected in a big way: skyscrapers. The Empire State Building, the Chrysler Building, and Rockefeller Center were crowning achievements of the late 1920s and early 1930s, and remain the dominant celebrities of the midtown skyline. Deco lobbies, theaters, jazz bars, restaurants, and details also hide and surprise at eye level across the city.

The text infuses the pictures with the astonishing energy of the time. Cab Calloway arrived before the George Washington Bridge was built and ferried across to join the great jazz swell, F. Scott Fitzgerald, Dorothy Parker and Robert Benchley's words emerged from its relentless vitality, Ayn Rand both mirrored and was influenced by its monumentality, lyricists like Lorenzo Hart turned "Manhattan into an isle of joy."

In architecture, "Deco" burst forth at full scale around 1925, when an expanding economy and a surging stock market stimulated an unprecedented exuberance on every level, cultural and commercial. Immigration fueled New York. Artists, musicians, writers, builders, and architects found a home in the city's incredibly diverse population and influences of every kind invaded its activities. Everything was possible in New York. No more gothic "Cathedrals of Commerce" or layer cakes of classicism: architects and titans of industry embraced the modern. The world's most modern metropolis suddenly seemed raring to look the part.

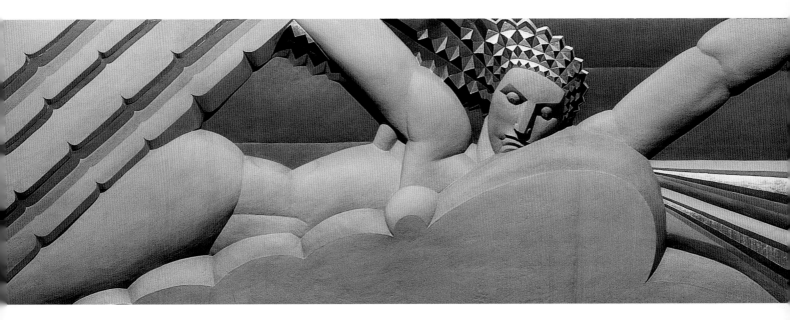

The New York style was eclectic, translated from many sources, but in particular, the influential 1925 Paris fair, the *Exposition des Arts Decoratifs et Industrielles*, where Beaux Arts classicism met cubism and abstraction and, in effect, created a middle-ground modernism. Other European influences, such as Viennese design and German Expressionist architecture, placed an emphasis on rich surface decoration, color, and dramatic lighting. The emphasis tended to be on walls with visual weight and architectural forms that seemed like sculpted masses—an aesthetic wildly geometric and filled with mythic and contemporary symbols from ancient gods to electricity. As buildings rose, praise for art, industry, science, workers, and commerce found its way into murals, mosaics, sculptures, ceilings, and walls. American modernism of the Deco era married simplified mass and rich ornament.

Richard Berenholtz captures these qualities in his sumptuous studies of Deco New York's fundamental forms and decorative details. He zooms in on the tops of towers, highlighting the faceted pyramids that seem carved out of solid stone or composed of thick bricks or terra-cotta panels. He revels in the telescoping circles of stainless steel in the Chrysler's crown and the radiating wings that buttress the Empire State's mooring mast. Close-ups of the most monumental forms find their counterpart in his enlargement of areas of decoration such as metal grilles, light fixtures, ornamental friezes, or thematic sculptural programs. He finds his quarry on facades, in lobbies, in plazas, elevators, and smoking rooms. New York is a Deco technicolor treasure hunt. Add to that the saturated hues of sunset skies and ultramarine nights, and the photographer, a master of the panorama, gives us a city where the romance of past styles remains an indelible presence.

Ｎew York is not hodgepodge in its architecture at all. Its ensemble is unique and anything but hodgepodge, as any photograph or distant perspective will prove.

Look at the Manhattan skyline and you will see a smoothly blended city. The beauty of its individual architecture is not surpassed anywhere in the world. Remember that New York is a constantly growing city, and that it has an architectural theme all its own. Rather than concede that it was hodgepodge, I would call it a patchwork of beauty.

—FIORELLO LA GUARDIA, 1939

PREVIOUS SPREAD: Located at 30 Rockefeller Center, the GE Building is adorned with Lee Lawrie's stylized relief *Wisdom with Light and Sound*. Sound is depicted on the left, Light on the right.

RIGHT: Originally intended to house the new Metropolitan Opera house, developer John D. Rockefeller and his team had to scramble for a new vision for Rockefeller Center when the opera pulled out in 1931. The result is a small wonder of Art Deco art and architecture, between 48th and 51st Streets and Fifth and Sixth Avenues, which includes a skating rink and an outdoor café. Completed in 1940, two of its most famous spots are Radio City Music Hall and the GE Building, center.

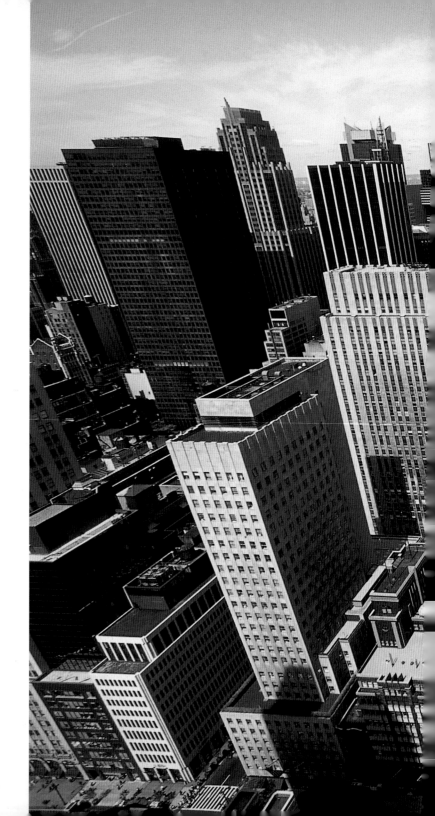

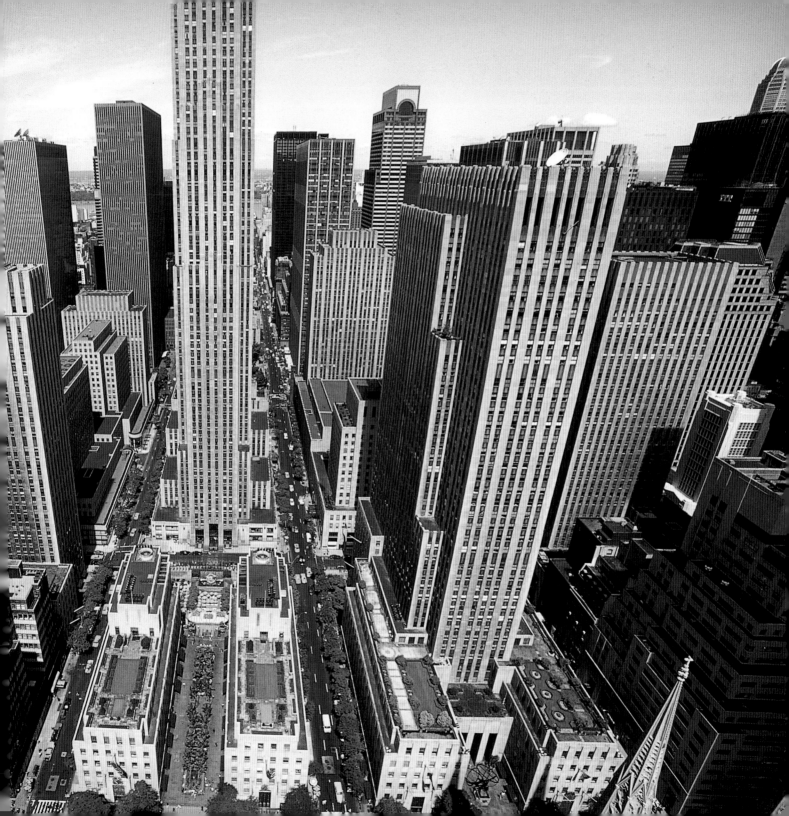

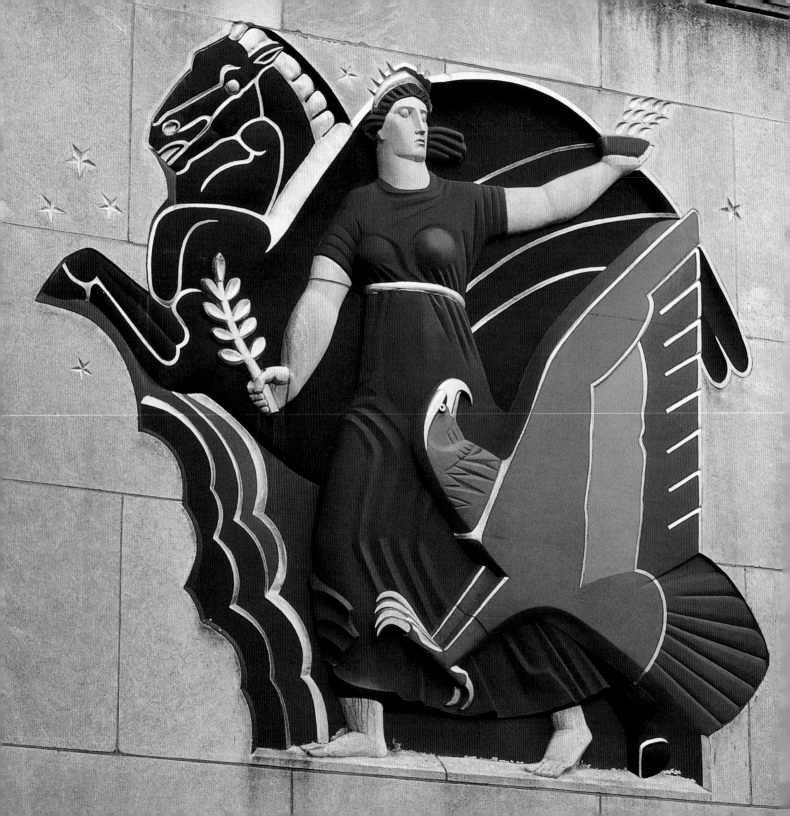

We opened at the Savoy in November 1929, barely a month after the crash. By the end of the year, investors had lost $40 billion and more than 6 million people were out of work, 5,000 banks had failed, and 32,000 businesses were bankrupt. There were breadlines everywhere and near-riots in New York. Everybody was angry with poor old Herbert Hoover. Everybody except people in the entertainment world, I guess. It's a funny thing, when things get really bad, when the bottom falls out of the economy, that's when people really need entertainment. . . . I suppose people figure, what the hell, let's go out and have a ball. It's one way to get out of the gloom. That's the way it was in 1929.

—CAB CALLOWAY

OPPOSITE: One of many Lee Lawrie bas-relief pieces in Rockefeller Center, this work at 14 West 49th Street depicts Pegasus—the mythical winged horse who symbolizes poetic genius—accompanied by the figures of a woman and a hawk.

OVERLEAF: Based on the guidance of consultant and philosopher Hartley Burr Alexander, the interior of 30 Rockefeller Plaza follows classic mythical themes. This 1933 José Maria Sert mural, found on the ceiling of the GE Building, praises modernity through the images of heroic figures at work.

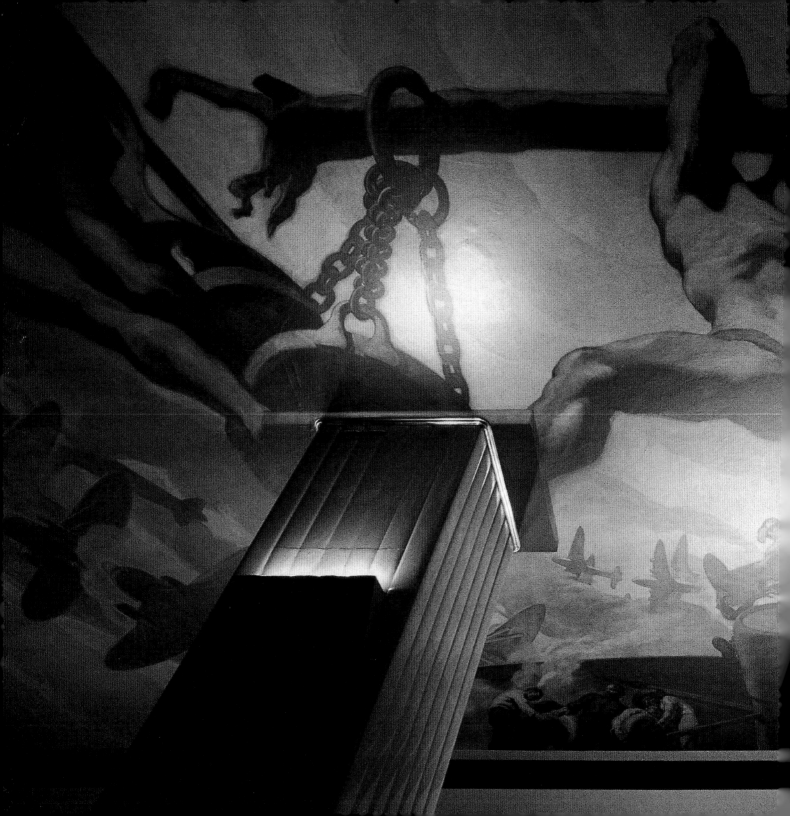

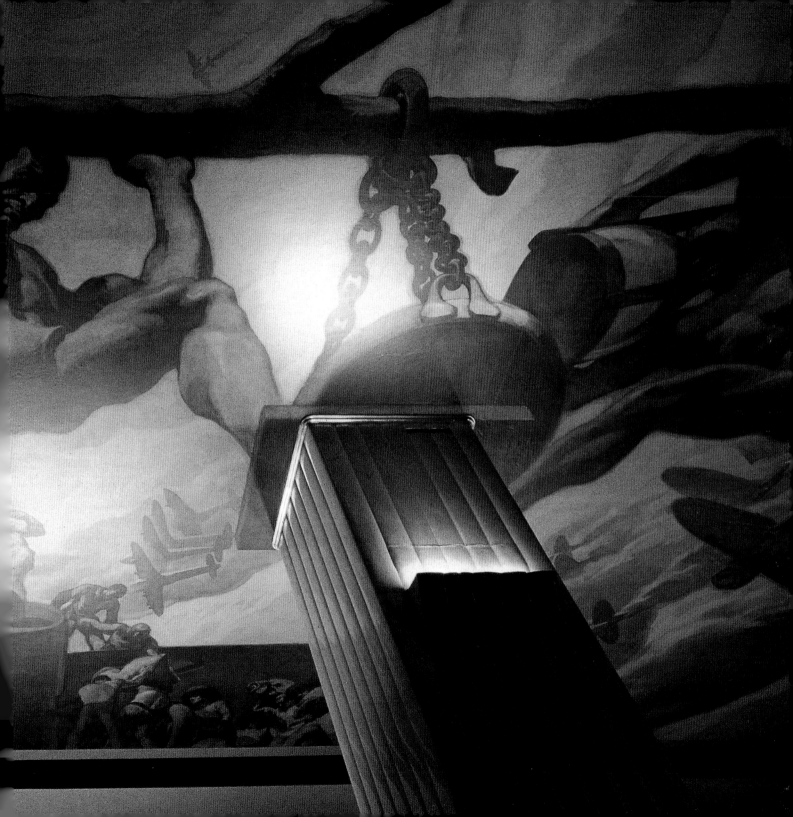

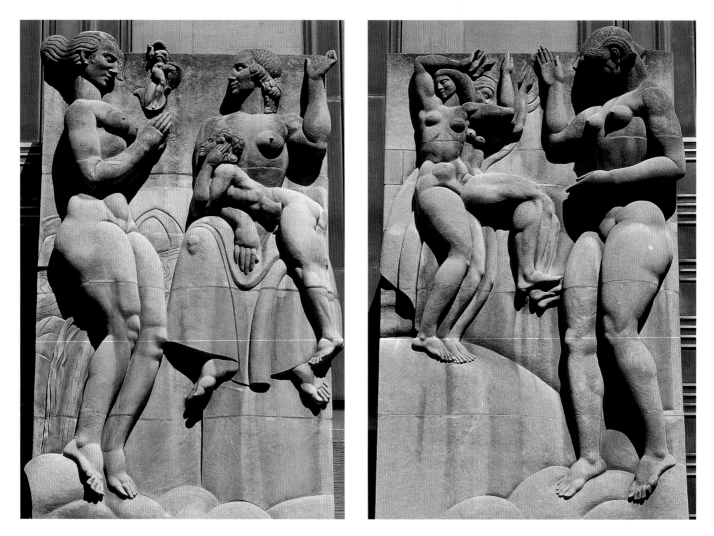

16

ABOVE: In 1932 the Rockefeller family put aside $150,000 for commissioned art in the plaza. Hundreds of pieces ranging from sculpture to paintings to bas-reliefs such as these now brighten the buildings of Rockefeller Center.

OPPOSITE: Lee Lawrie's bas-relief masterpiece at 25 West 50th Street in Rockefeller Center measures in its entirety 15 1/2 x 21 1/2 feet, a size matched only by its title: *The Genius Who Interprets to the Human Race the Laws and Cycles of the Cosmic Figures of the Universe, Making the Cycles of Sight and Sound.* Beginning at the bottom, the piece shows four races of humankind, a trade ship, and figures of art, science, and industry.

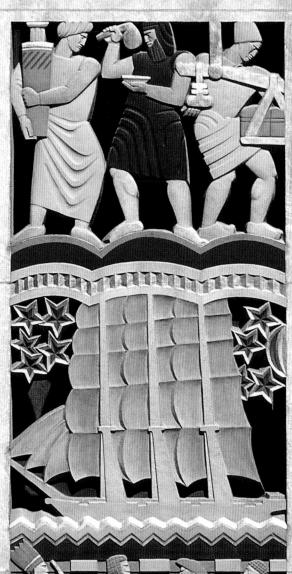
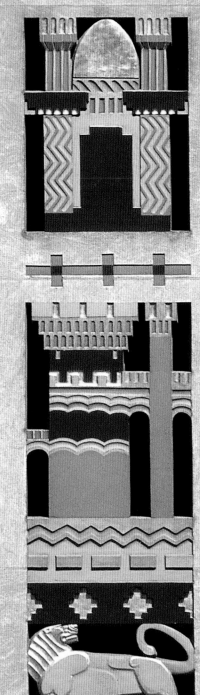
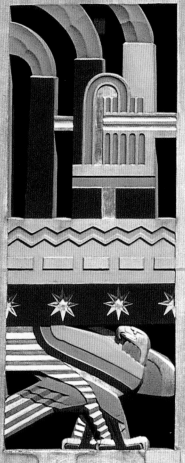
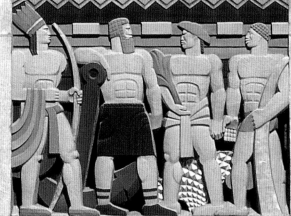

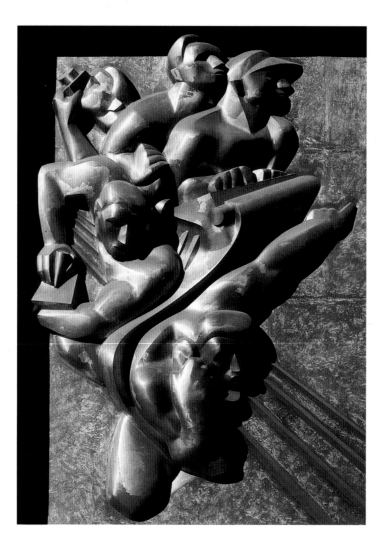

ABOVE: 50 Rockefeller Plaza housed the Associated Press from 1938 to 2004. In honor of the AP's work, Japanese American artist Isamu Noguchi created this stainless-steel bas-relief titled *News* in 1940.

OPPOSITE: The majority of the art in Rockefeller Center is allegorical. Nearly all the decorative features, including these mosaics, tell stories stressing the importance of education, wisdom, and international trade. This particular scene, at the 1250 Avenue of the Americas entrance to the GE/RCA building, represents ignorance.

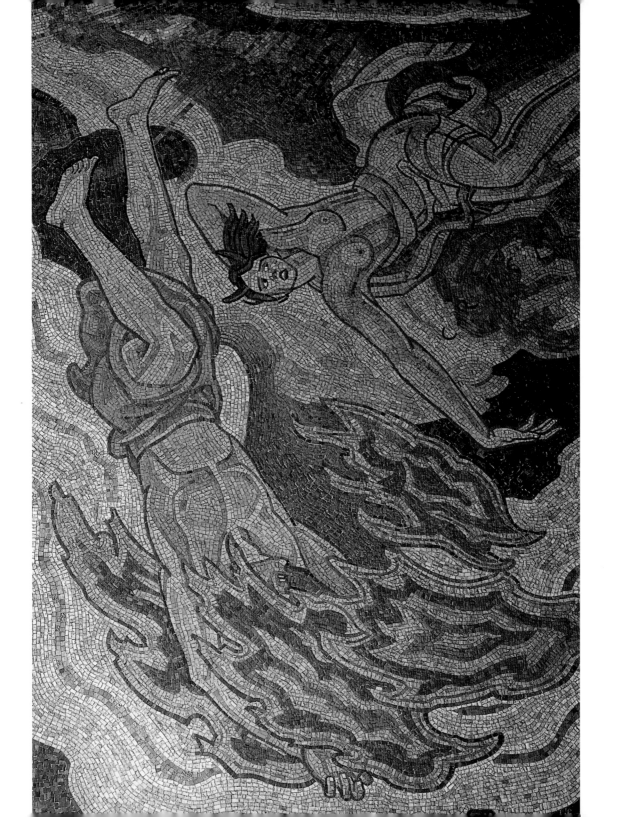

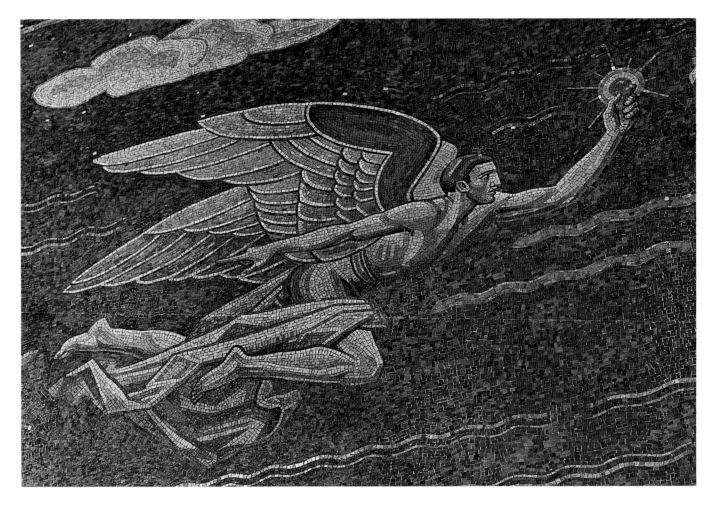

The male figure above—found on the entrance to 1250 Avenue of the Americas—
represents biology; the female figure opposite represents poetry.

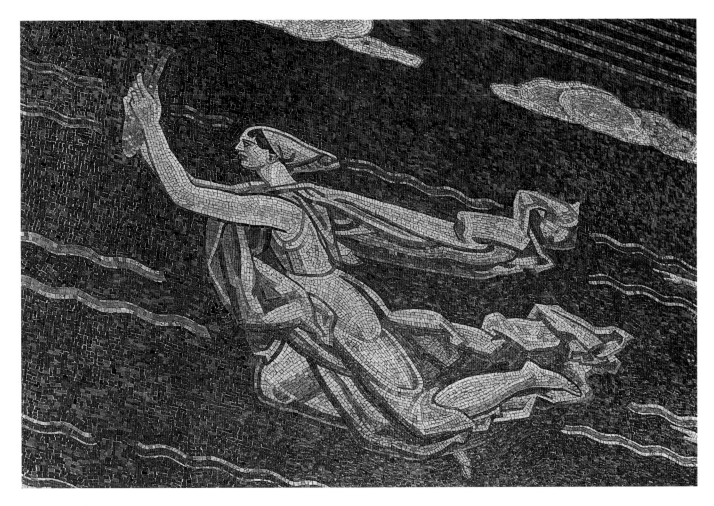

It seemed almost intolerably shining, secure and well-dressed, as though [New York]
was continually going to gay parties while London had to stay home and do the housework.

—NOEL COWARD

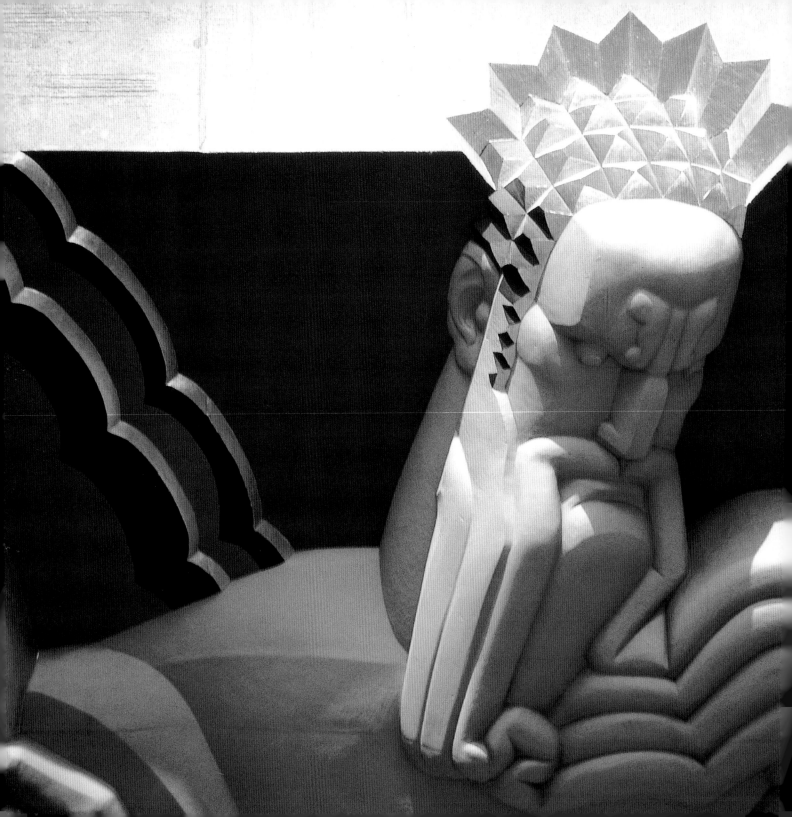

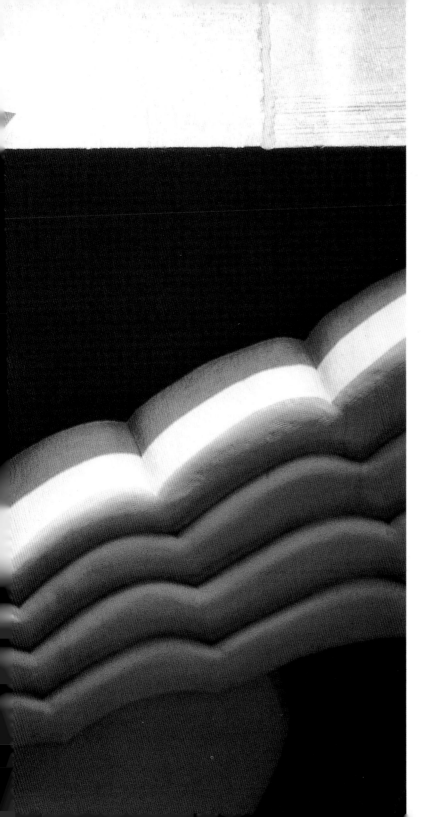

New York is constructed to the scale of the United States, as Athens was built for the Greek Republic, and Paris for the kingdom of France. The very thing that I admire most in New York is its adaptation to the continent. In this sense, its architecture is intellectually reasonable, logical and beautiful.

—BERNARD FAY, 1929

23

Lee Lawrie, the most prolific artist in Rockefeller Plaza, is best known for his Atlas sculpture and for this relief of *Wisdom with Light and Sound* (with "Wisdom" depicted here), which is situated over the main entrance, at "30 Rock."

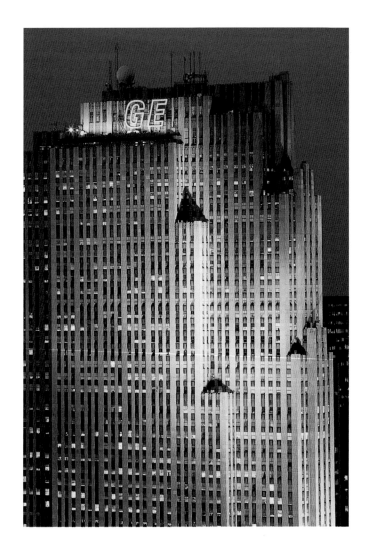

24

ABOVE: Built in 1933 for the Radio Corporation of America—and later taken over by General Electric—
the seventy-story building at 30 Rock is by far the tallest in Rockefeller Center. The limestone skyscraper features
jagged setbacks near the top that are common to the Art Deco era.

OPPOSITE: This two-ton statue of Atlas carrying the heavens upon his shoulders is the largest sculptural work in
Rockefeller Center. Designed in 1936 by Lee Lawrie and René Chambellan, the Art Deco style is apparent in the statue's
exaggerated musculature and streamlined curves.

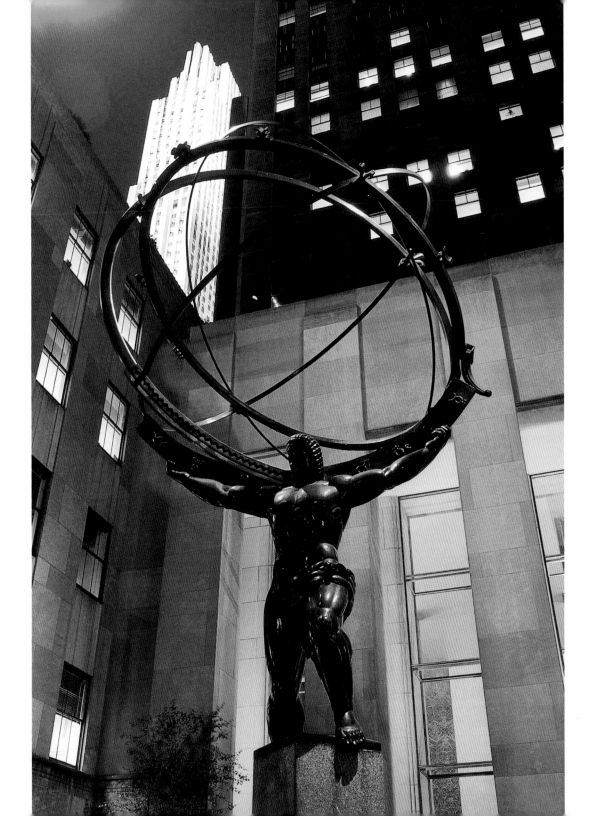

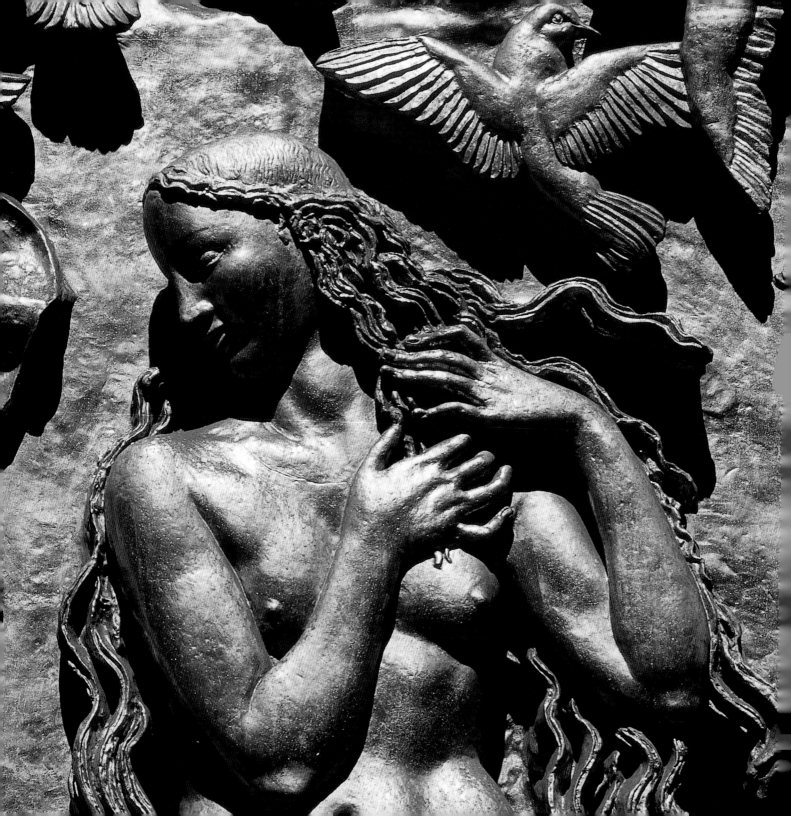

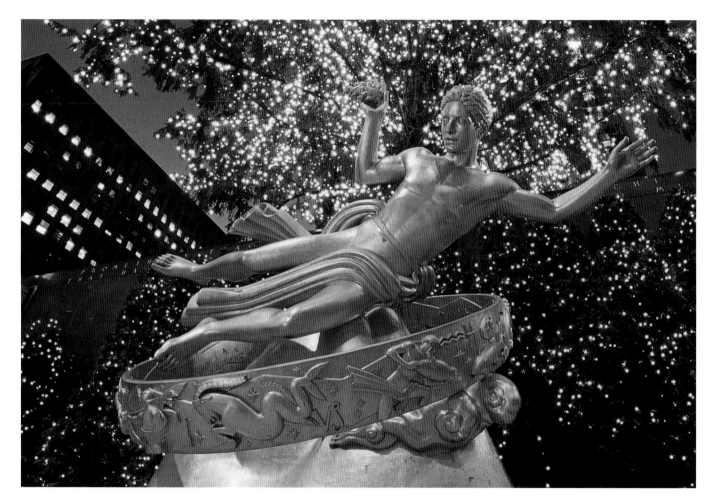

OPPOSITE: On the west end of Rockefeller Center, La Maison Francaise was built at 610 Fifth Avenue in 1933. The exterior contains this gilded bronze bas-relief by Alfred Janniot, *The Friendship of France and the United States.*

ABOVE: Prometheus, in Rockefeller Center's lower plaza, with a magnificent backdrop of twinkling holiday lights. Paul Manship created this gilded bronze sculpture in 1934, depicting Prometheus descending from Mount Olympus and surrounded by the zodiac ring. He is credited in Greek mythology for teaching man to make fire, hence the ball of fire in his right hand.

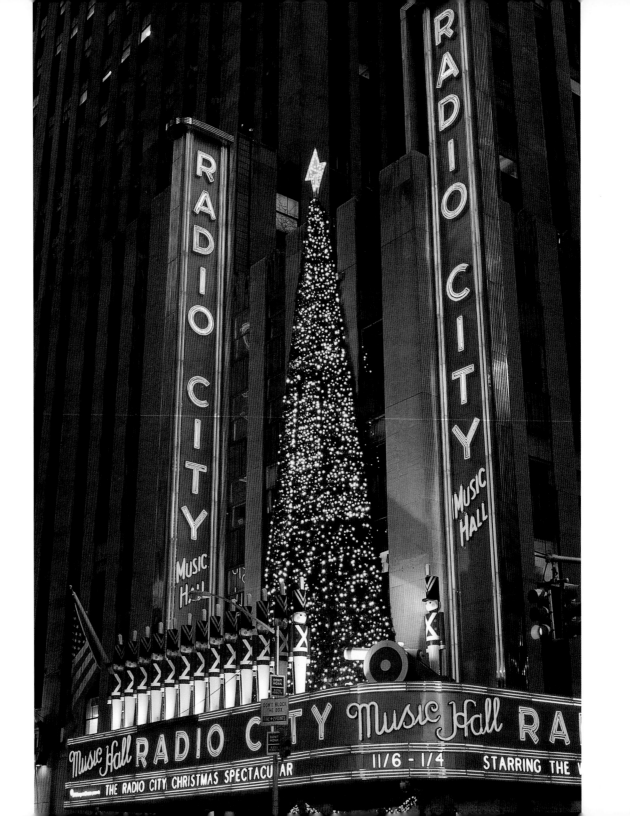

For most visitors to Manhattan, both foreign and domestic, New York is the Shrine of the Good Time. This is only natural, for outsiders come to New York for the sole purpose of having a good time, and it is for their New York hosts to provide it. The visiting Englishman, or the visiting Californian, is convinced that New York City is made up of millions of gay pixies, flitting about constantly in a sophisticated manner in search of a new thrill. "I don't see how you stand it," they often say to the native New Yorker who has been sitting up past his bedtime for a week in an attempt to tire his guest out. "It's all right for a week or so, but give me the little old home town when it comes to *living*." And, under his breath, the New Yorker endorses the transfer and wonders himself how he stands it.

—ROBERT C. BENCHLEY, 1928

The famous Radio City Music Hall neon marquee during the Christmas season.
Sited on the corner of Sixth Avenue and 50th Street, the theater is home to the Radio City
Christmas Spectacular, a show starring the high-kicking Rockettes.

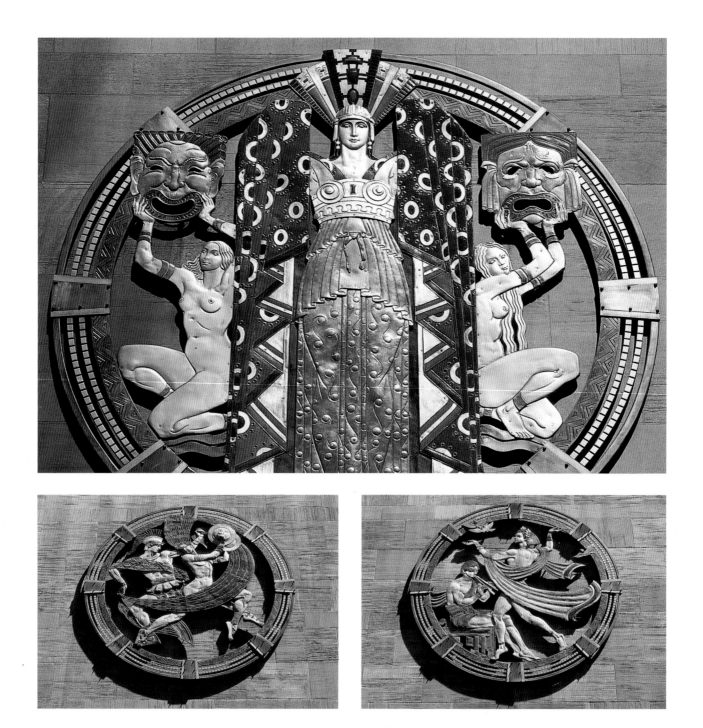

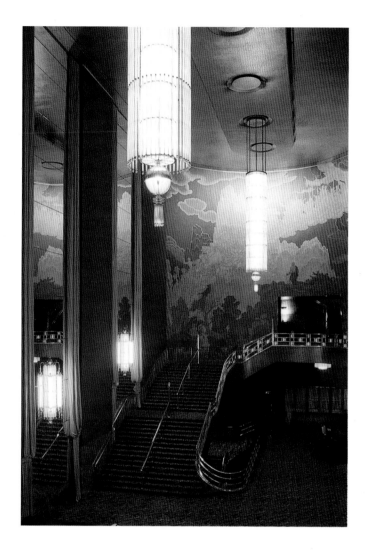

OPPOSITE: Radio City Music Hall was built by John D. Rockefeller Jr. and architect Edward Durell Stone in 1932 as an expression of hope in the midst of the Great Depression. Above the marquee are three plaques by Hildreth Meiere with heroic figures depicting theater, dance, and music in rich blue and gold coloring.

ABOVE: Since its opening in December 1932, more than three hundred million people have visited Radio City Music Hall. The world's largest indoor theater was designed and planned by Stone, but the impressive Art Deco interior was created by Donald Deskey. Here on the grand staircase is Ezra Winter's elaborate mural *Fountain of Youth*, a piece so large that it had to be painted on a tennis court and transported to the hall in sections.

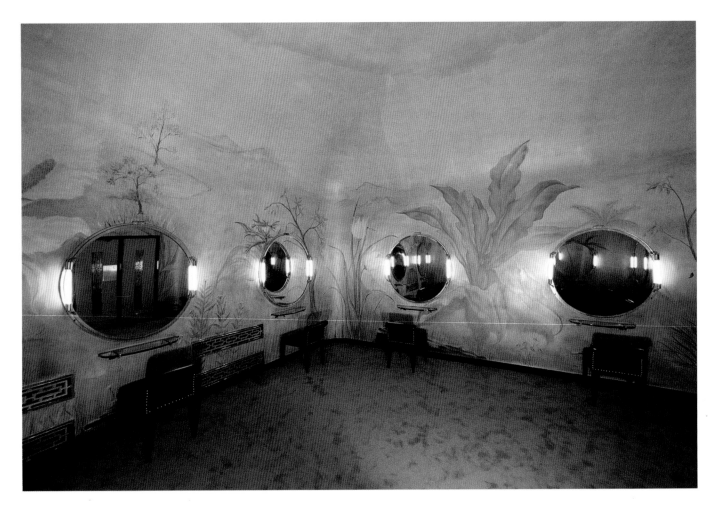

ABOVE: Radio City was created with the idea that it should be a place where ordinary people feel like royalty. The women's lounge, with a floral mural by Yasou Kuniyoshi, is a shining example of a space that provides the ultimate sense of luxury for theatergoers.

OPPOSITE: Deskey designed Radio City Music Hall with the theme of "The Progress of Man." In the men's smoking room, the theme is illustrated by maps that celebrate man's dominion over the world.

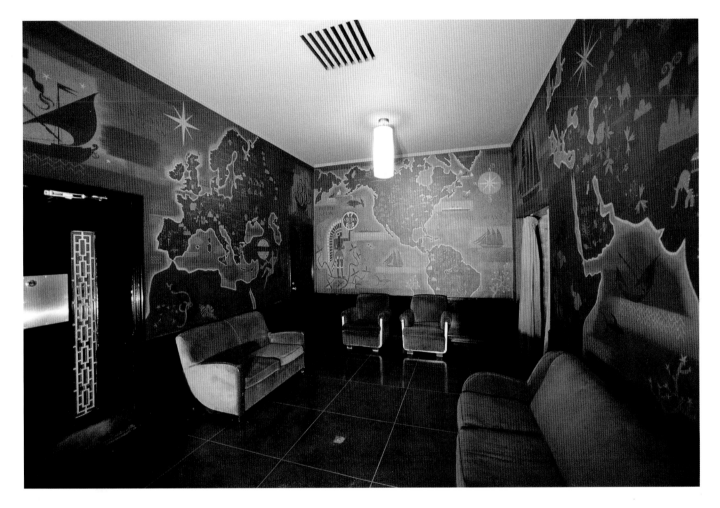

I miss the animal buoyancy of New York, the animal vitality.
I did not mind that it had no meaning and no depth.

—ANAÏS NIN, c. 1930

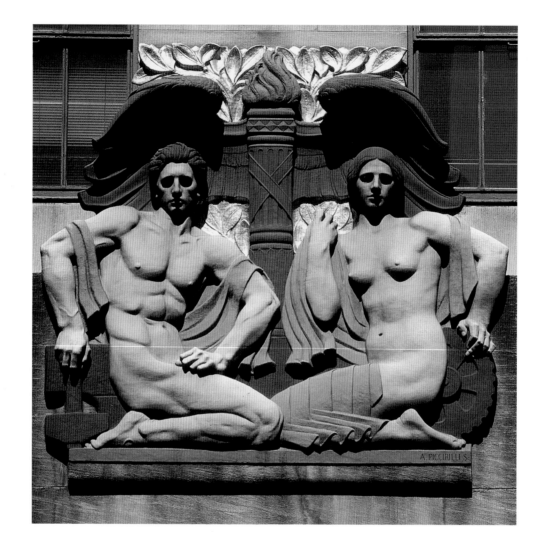

34

ABOVE: Located at 636 5th Ave., the International Building has extraordinary examples of how philanthropist and developer John D. Rockefeller created the Plaza to be a thoughtful environment, steeped in allegorical art. This bas-relief shows two heroic figures of worldly trade.

OPPOSITE: Next door to Rockefeller Center at 608 Fifth Avenue is the Swiss Center. An official city landmark, the small eleven-story edifice was built by Robert Goelet in 1931 with the assistance of E. H. Faile & Company. Solid stripes of black and brown marble frame the lobby's pièce de résistance, the handsome gold-and-silver elevator doors.

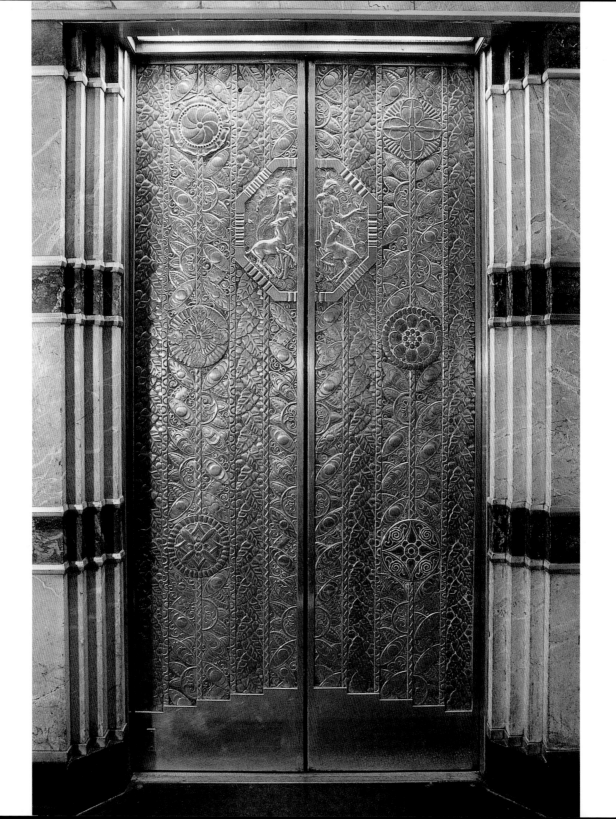

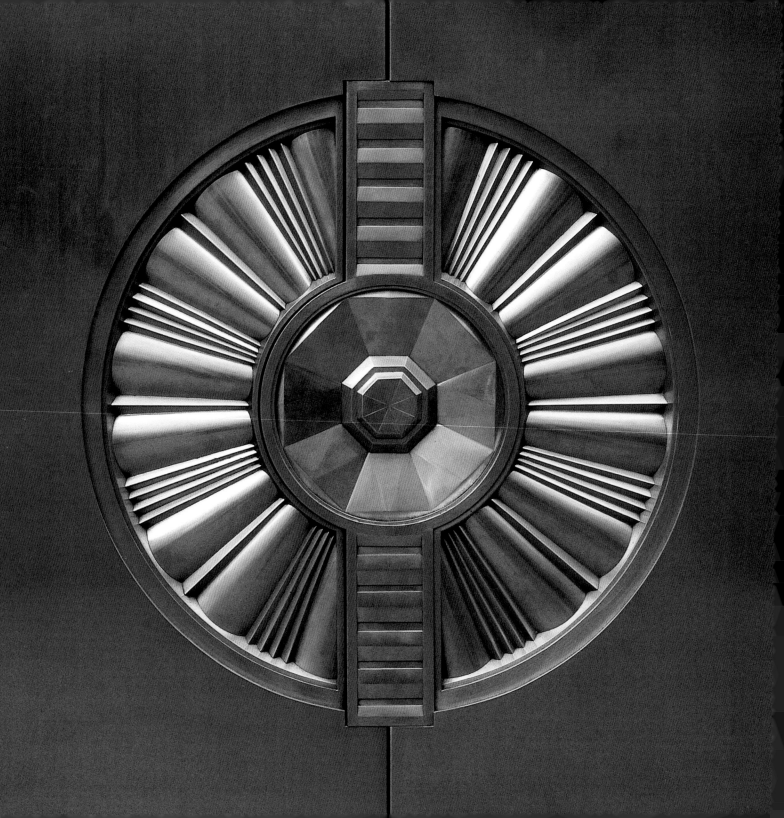

MONDAY. Breakfast tray about eleven; didn't want it. The champagne at the Amorys' last night was *too* revolting, but what *can* you do? You can't stay until five o'clock on just *nothing*. They had those *divine* Hungarian musicians in the green coats, and Stewie Hunter took off one of his shoes and led them with it, and it *couldn't* have been funnier. He is *the* wittiest number in the *entire* world; he *couldn't* be more perfect. Ollie Martin brought me home and we both fell asleep in the car—*too* screaming. Miss Rose came about noon to do my nails, simply *covered* with the most divine gossip. The Morrises are going to separate *any minute*, and Freddie Warren *definitely* has ulcers, and Gertie Leonard simply *won't* let Bill Crawford out of her sight even with Jack Leonard *right there in the room*, and it's all *true* about Sheila Phillips and Babs Deering. It *couldn't* have been more thrilling. Miss Rose is *too* marvelous; I really think that a lot of times people like that are a lot more intelligent than a lot of people. Didn't notice until after she had gone that the damn fool had put that revolting tangerine-colored polish on my nails; *couldn't* have been more furious. Started to read a book, but too nervous. Called up and found I could get two tickets for the opening of "Run like a Rabbit" tonight for forty-eight dollars. Told them they had *the* nerve of the world, but what *can* you do? Think Joe said he was dining out, so telephoned some *divine* numbers to get someone to go to the theater with me, but they were all tied up. Finally got Ollie Martin. He *couldn't* have more poise, and what do *I* care if he *is* one? *Can't* decide whether to wear the green crepe or the red wool. Every time I look at my finger nails, I could *spit*. *Damn* Miss Rose.

—DOROTHY PARKER, 1933

Opening its doors in 1940, Tiffany & Co.'s move to 749 Fifth Avenue created a new upper-class shopping destination directly below Central Park. The building was the first to have central air-conditioning as a principal part of the design, though it's just one of the ways the store glamorized itself. Another is through the use of delicate silver designs on the exterior of the building.

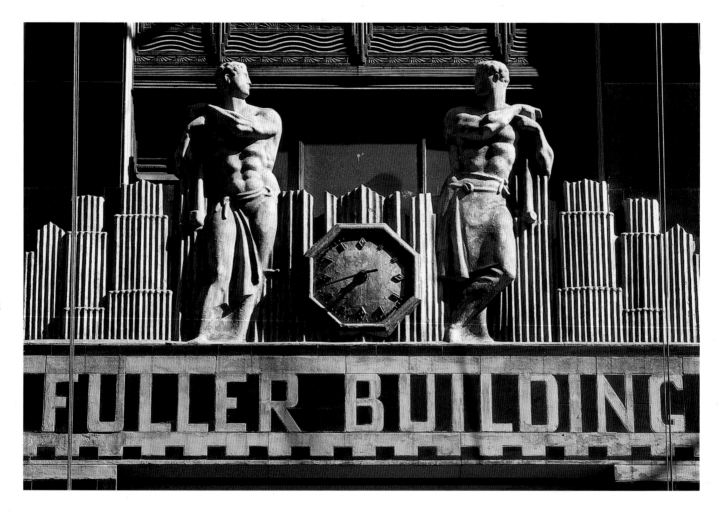

38

ABOVE: The entrance to Walker & Gillette's Fuller Building at 41–45 East 57th Street is enhanced by this clock created by Elie Nadelman in 1929, which portrays a view of New York's skyline and its workers.

OPPOSITE: The graceful steplike recessions at the top of the Fuller Building provide a sense of movement intrinsic to the era. Other Art Deco features include black and gold marble, geometric shapes, and sunburst patterns.

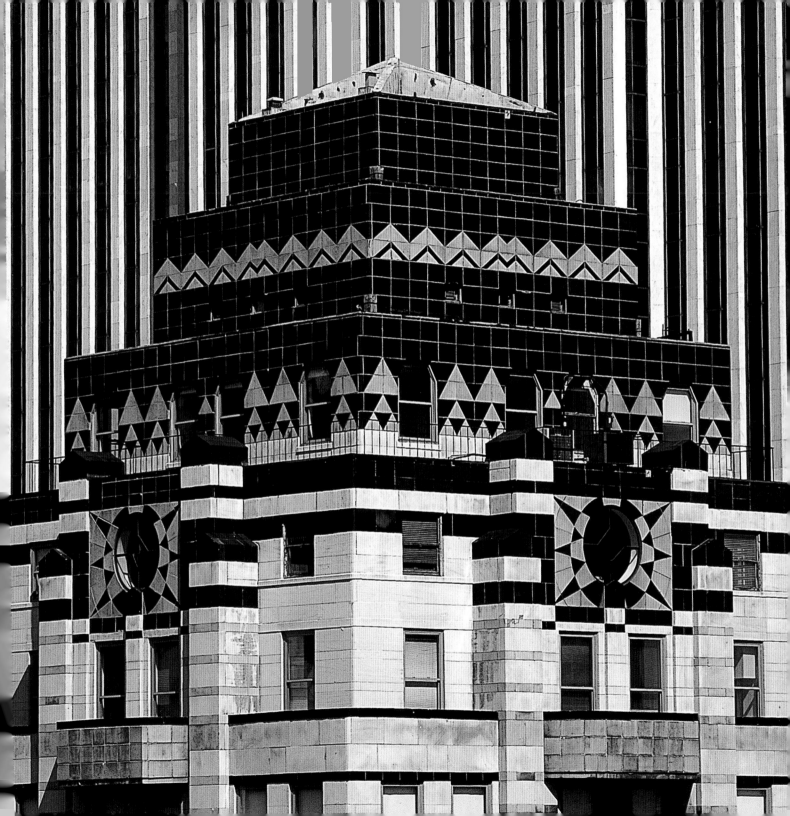

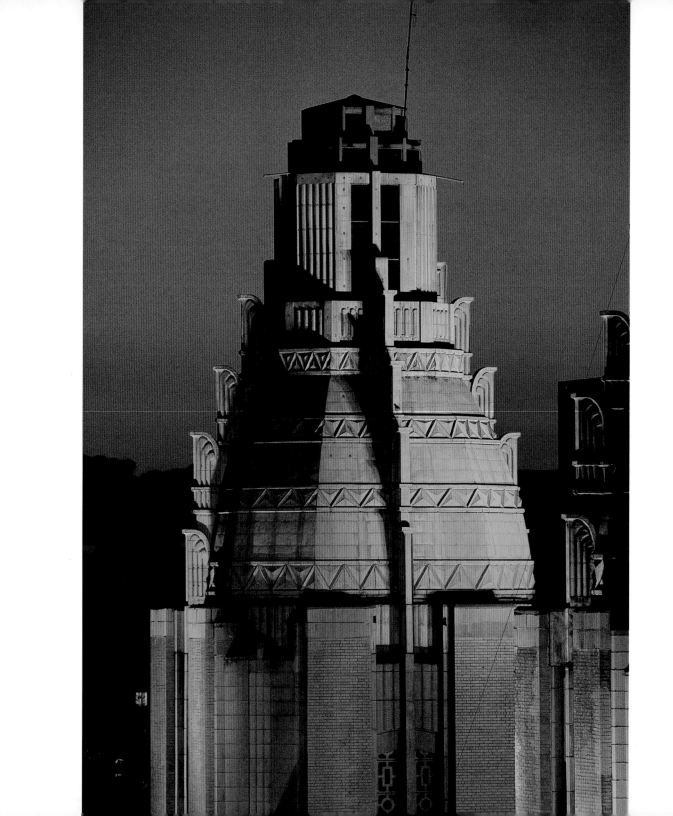

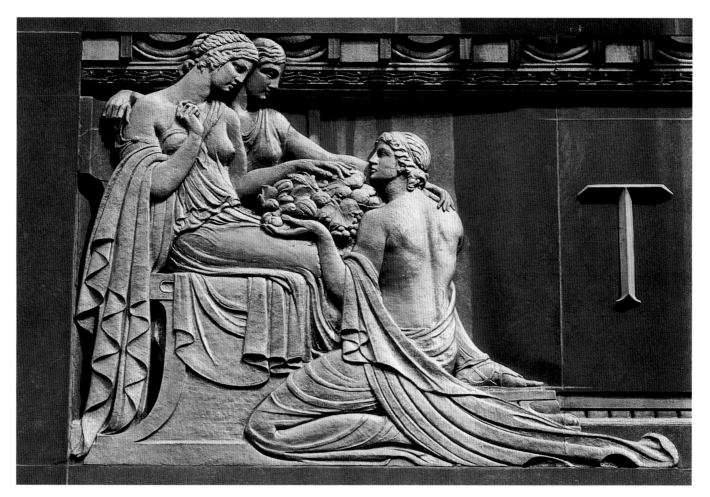

41

OPPOSITE: The new Waldorf-Astoria hotel was built at Park Avenue between 49th and 50th Streets between 1929 and 1931. The original hotel site was being demolished to make way for the Empire State Building, and architects Schultze & Weaver wanted the new Waldorf to rival its predecessor. The hotel's two limestone-and-grey-brick towers, seen here at dusk, ensured that the forty-two-million-dollar hotel would have a place of prominence in the New York skyline.

ABOVE: The meeting place for high society, the Waldorf's interior embraced all things extravagant, including murals, a two-ton clock, and a suite designed especially for the President of the United States. In contrast, the exterior is relatively unadorned—with the exception of its entrance, highlighted by this gold Art Deco relief work.

N ew York is, after all, a place of business; it is not constructed to be lived in.

—WYNDHAM LEWIS

This impressive elevator lobby in the Waldorf Astoria hotel has stunning murals that sweep across the arched ceiling and draw attention to the gilded chandeliers.

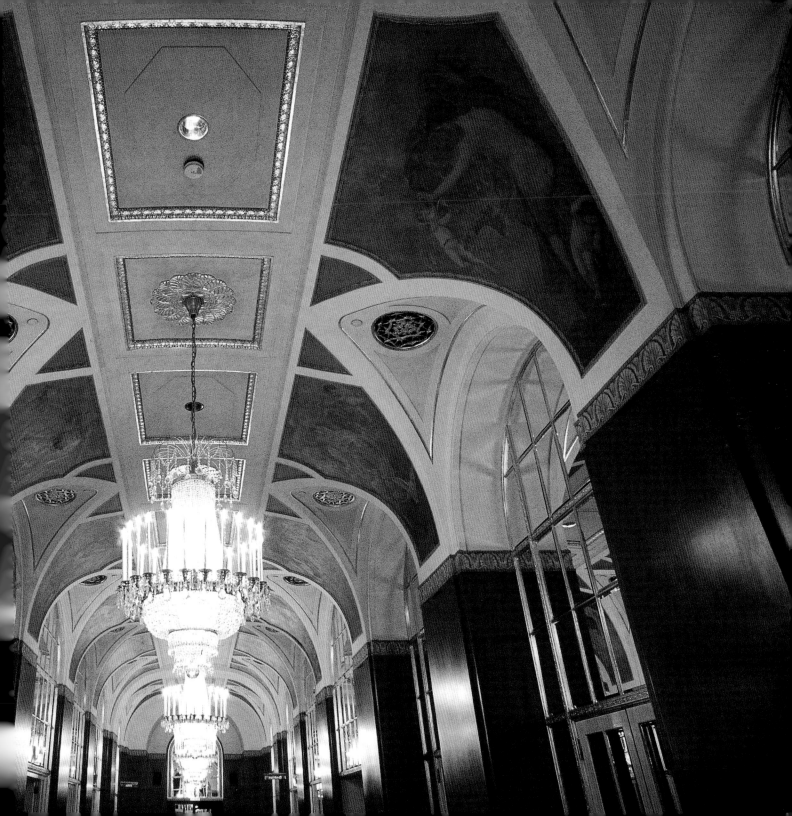

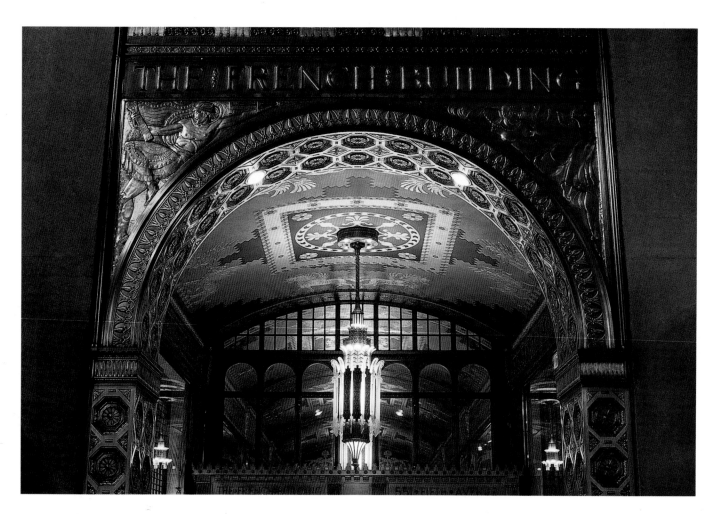

44

ABOVE: When the Fred F. French Building was constructed in 1927 at 551 Fifth Avenue, architect H. Douglas Ives embraced the grandeur of the period by constructing this limestone base adorned with a massive bronze arch, which is detailed with a traditional motif often found in Art Deco design.

OPPOSITE: Elements such as bronze paneling and vibrant terra-cotta ornamentation by Douglas Ives and Sloan & Robertson allude to ancient Middle Eastern motifs and colors.

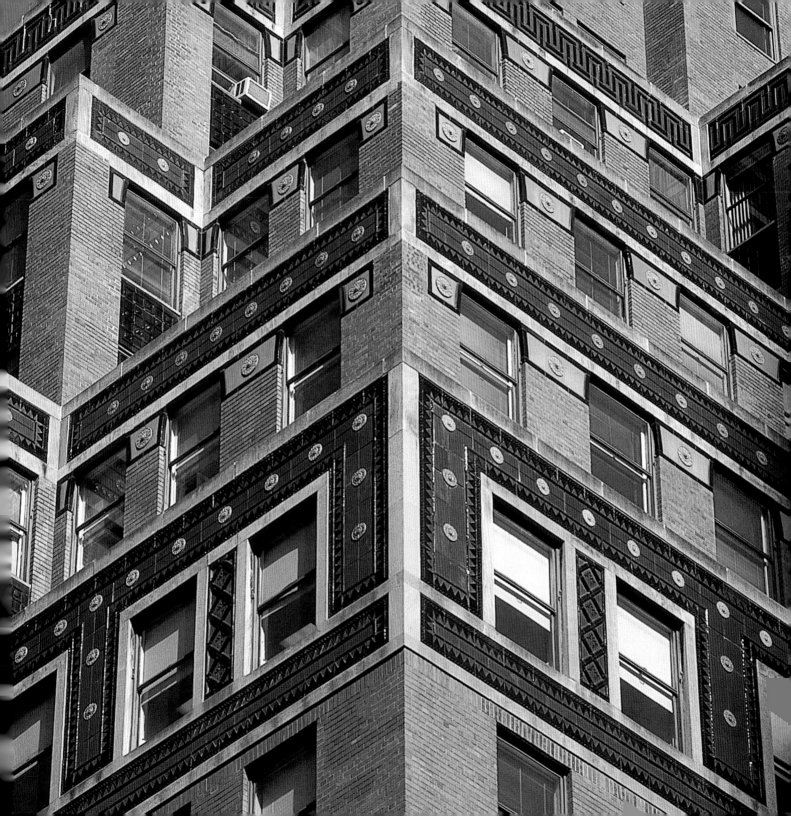

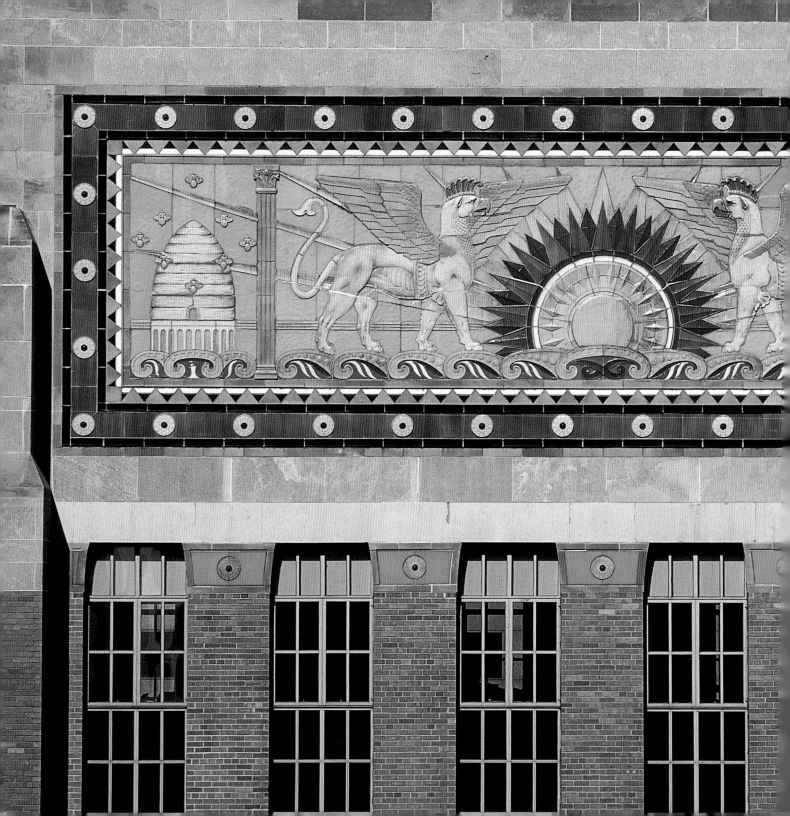

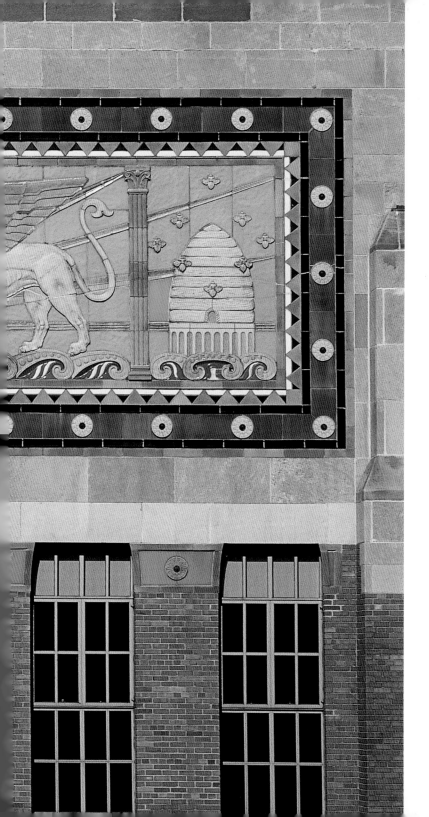

I like Americans.

They carry such pretty umbrellas.

The Avenue de l'Opéra on a rainy day

 is just an avenue on a rainy day.

But Fifth Avenue on a rainy day is an

 old-fashioned garden under a shower. . . .

 —EDNA ST. VINCENT MILLAY, 1924

47

Terra-cotta panels on the roof's crest of the French Building
expand on the neo-Assyrian decoration with winged lions, a
rising sun, and beehives (of industry). Panels containing
strong allegorical themes, along with geometric patterns, were
fundamental to the Art Deco visual vocabulary.

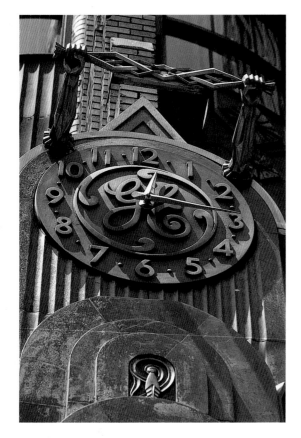

ABOVE: The GE clock at 570 Lexington Avenue features sculpted arms holding a beautifully ornate wave of electricity.

RIGHT: What is known now as the old General Electric Tower was originally designed by architect Cross & Cross in 1931 for the RCA-Victor Corporation. Its breathtaking crown features lightning bolts, curved lines, and spikes of rose-colored limestone that pay tribute to the electricity of RCA's radio transmission waves. Later both RCA and GE would move into the prosperous Rockefeller Center.

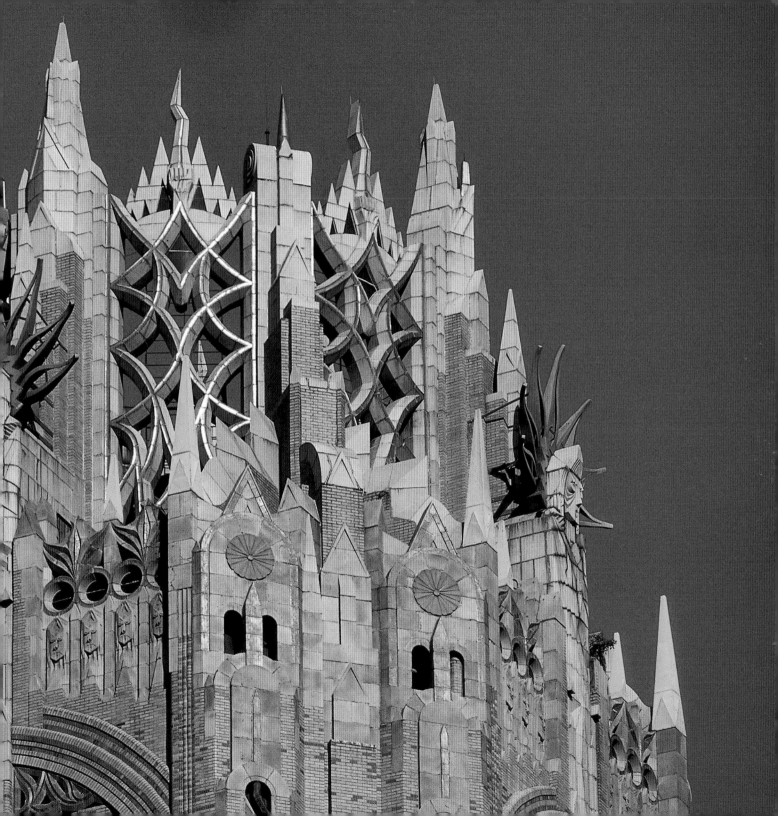

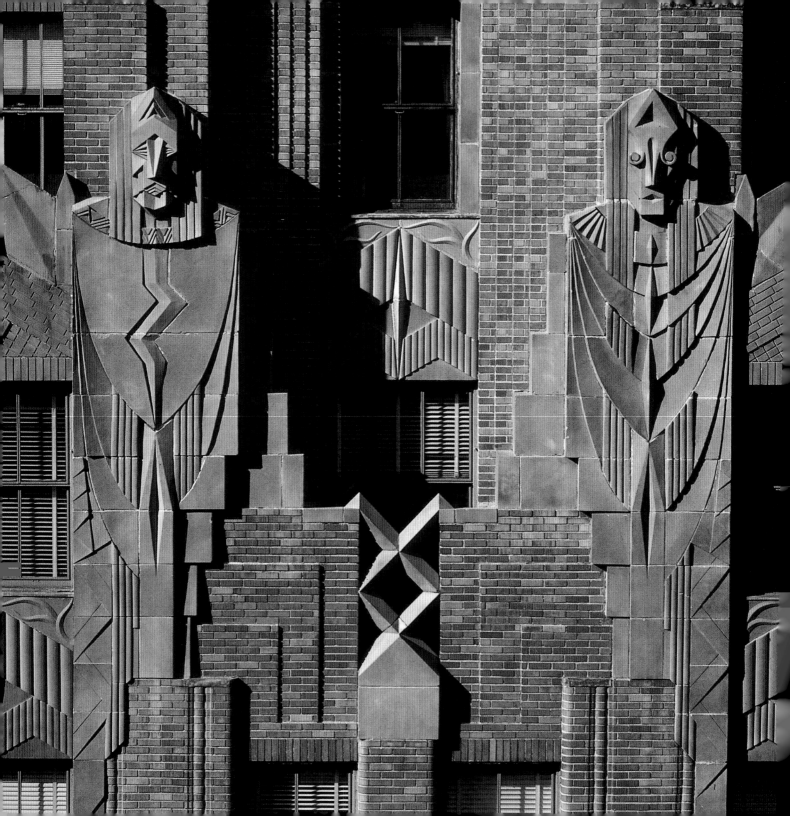

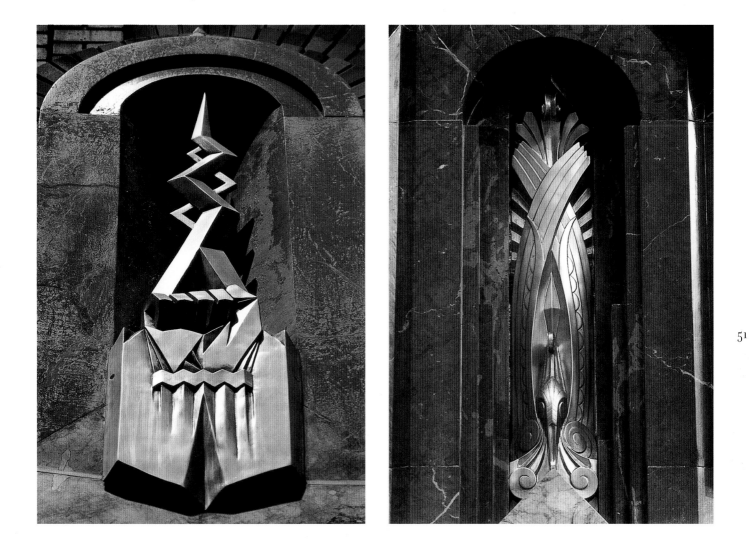

51

OPPOSITE: In creating the RCA-Victor/General Electric Tower, Cross & Cross was challenged by its need to fit visually with its neighbor, St. Bartholomew's Episcopal Church, while adapting its ornament to its modern subject. The firm accomplished its first goal by using granite and glazed brick that matched the coloring of the church, and by designing these classical figures to symbolize the power of electricity.

ABOVE: Among the ornamental touches on the exterior of the RCA-Victor/General Electric Tower are the silver detailing of a lightning bolt and bird.

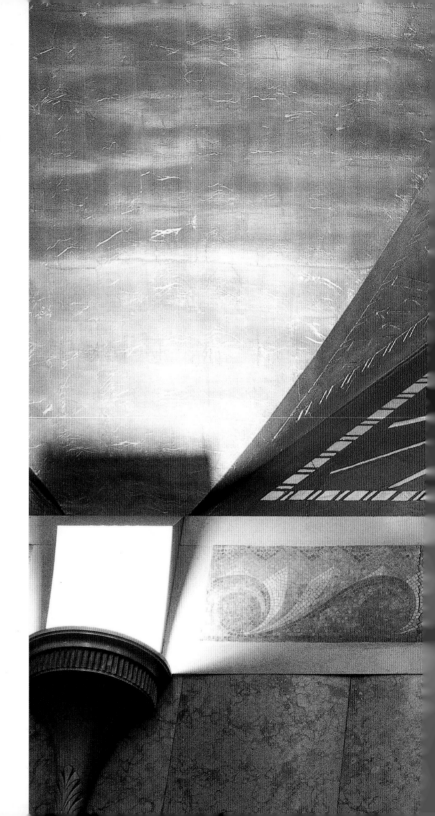

One lived, here in New York, upon ultimate edge of life, a kind of hyperborean edge midmost the temperate zone; the border of a perpetual shadow. For behind us, to the west, a continent lay submerged in chaotic pre-creation darkness. Movement, noise, rise and fall of perpetually displaced matter, all these seeming products of sun-power, were unsubstantial quite, dusty mirages of all the senses. For the very heat was not here. Or merely faintly enough to let us know what it was we wanted. Nothing moved indeed. Nothing came to relation.

—PAUL ROSEFELD, 1924

52

The lobby of the RCA-Victor/GE Building was designed with a vaulted ceiling and aluminum plating. Cross wanted its vertical lines and sunbursts to intersect with the curves in the structure to further convey the directness of radio.

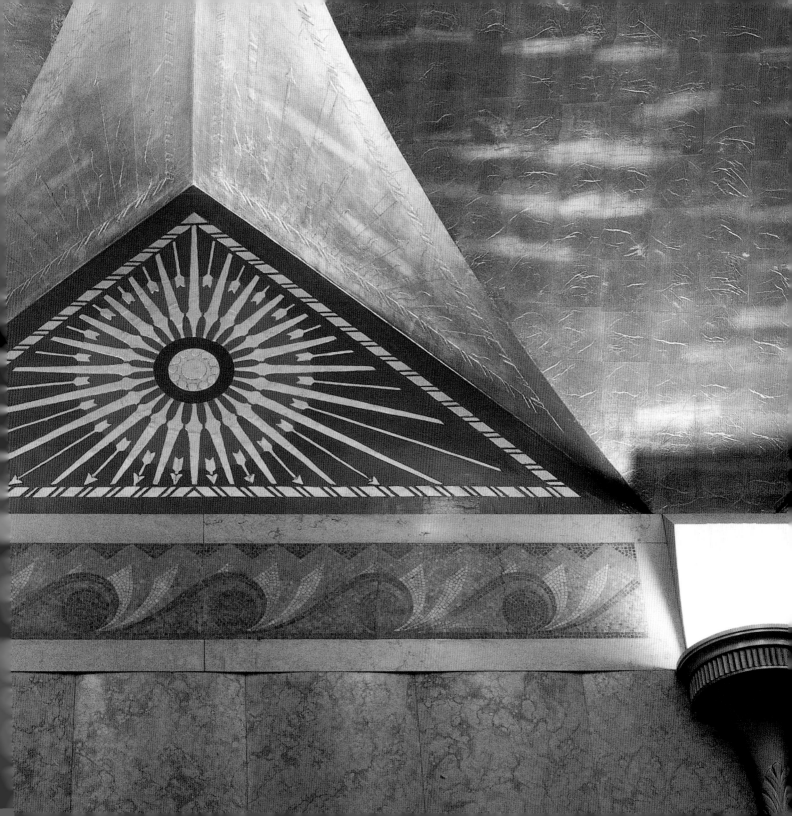

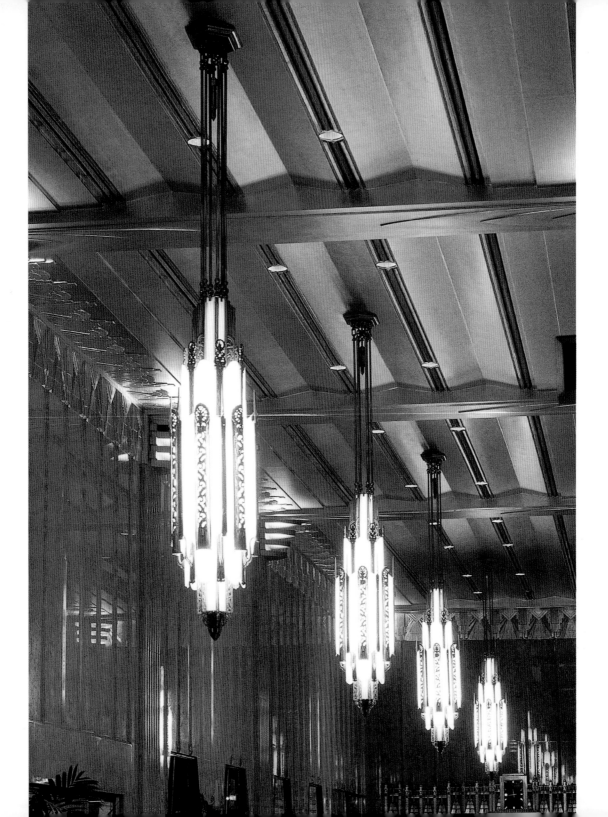

54

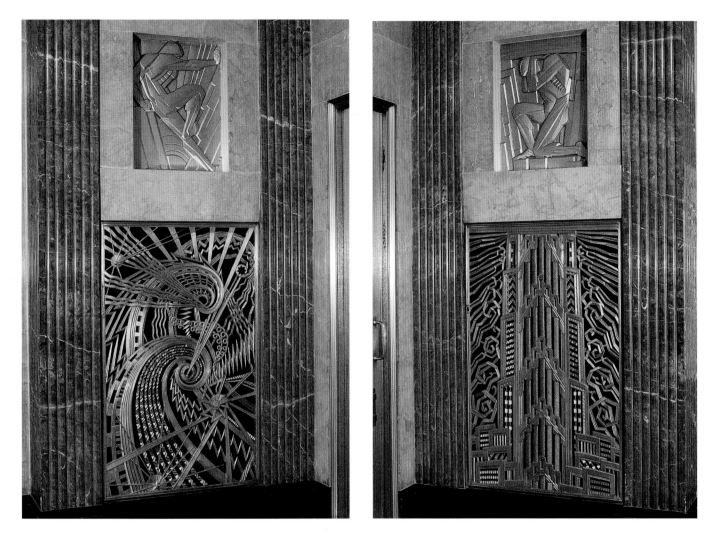

OPPOSITE: Built in 1929 developer Irwin Chanin, the lobby of the Chanin Building, at 122 East 42nd Street, was meant to celebrate his own rise to wealth through exuberant pieces such as René Chambellan's bronzework and these exquisite light fixtures, featured in the lobby design by archtiect Jacques Delamarre.

ABOVE: After visiting Paris in 1925 and touring the Exposition Internationale des Arts Decoratifs, Chanin returned to New York filled with new ideas for his buildings. Inspired by the French styles, Chambellan's bronze grilles and reliefs have mechanical zigzags and curves that show a city of opportunity and its workers.

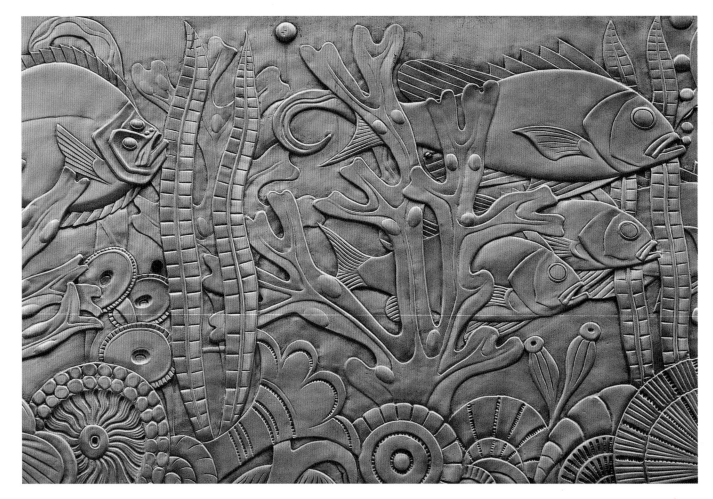

ABOVE: The Chanin Building has a spectacular bronze frieze that runs above storefront level and tells an interesting story of evolution. From left to right, it traces the evolution of a small amoeba that becomes a jellyfish, which swims along to become a fish, which ends up as a goose.

OPPOSITE: Geometric Deco patterns and bold arches dominate a private bathroom in the Chanin Building.

ABOVE: Low-relief ornamentation by doors and windows represents a standard design in Art Deco–style architecture, as can be seen here on the 1927 Graybar Building by Sloan & Robertson. These vibrantly colored figures decorate the exterior of 420 Lexington Avenue, once home to one of the highest-grossing electrical equipment manufacturer of its time, Gray & Barton.

OPPOSITE: Art Deco mixes classical design with cubist-style pieces, creating a unique look. An example of this is present in the Graybar Building, which is adorned with several images of gilded gods and also has a vibrant red-and-gold entrance with newly renovated Art Deco signage.

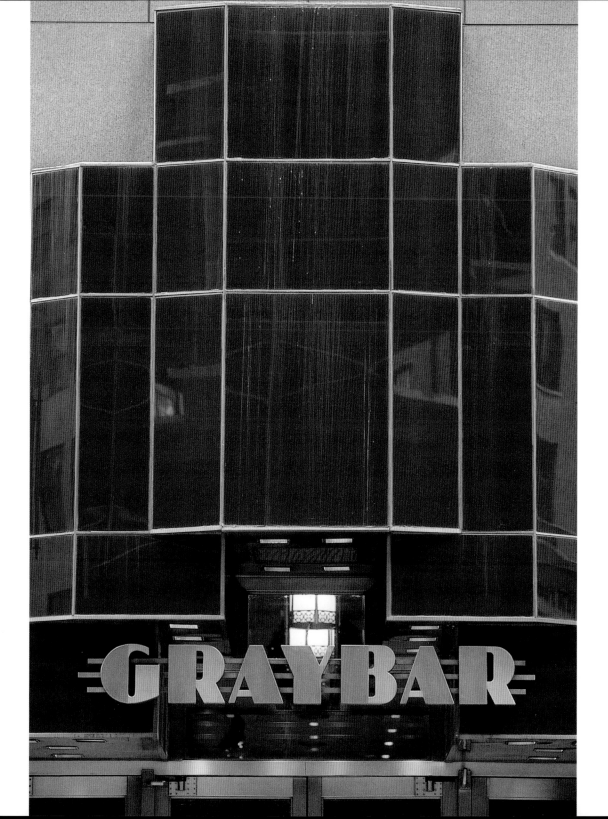

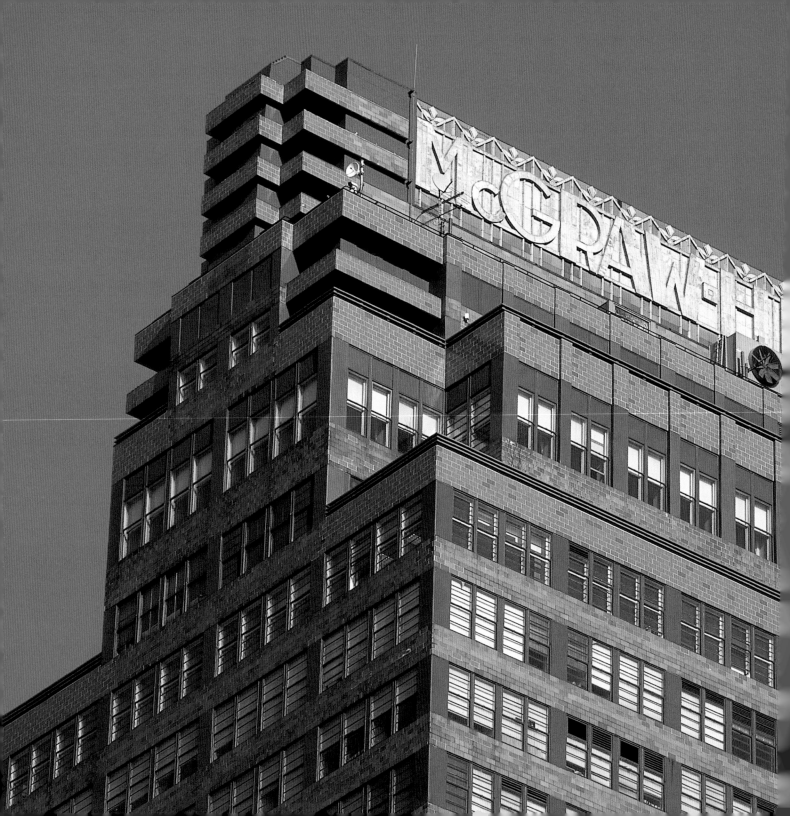

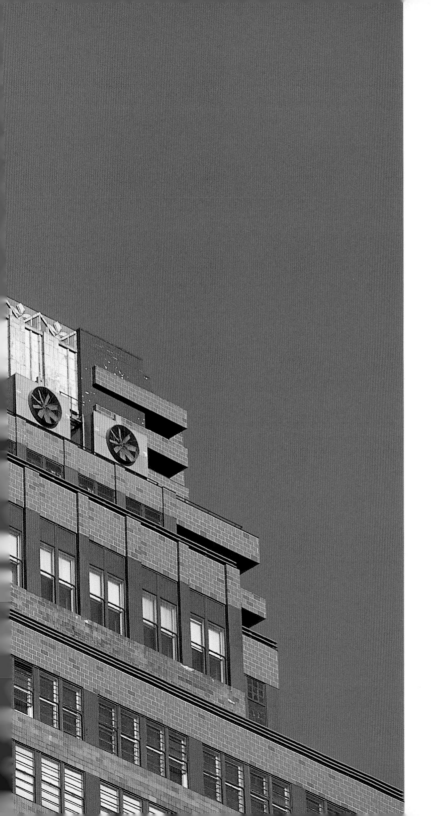

The skyline of New York is a
monument of splendor that no pyramids
or palaces will ever equal or approach.

—AYN RAND

Nicknamed "The Jolly Green Giant" in 1931 for its glazed
blue-green tiles, the McGraw-Hill Building at 330 West 42nd
Street continued Raymond Hood's vision of colorful and
modern buildings. While also designing Rockefeller Center,
Hood crowned the McGraw-Hill Building with a stylized top
that featured the company's name.

N ew York has enveloped
itself for me in a haze of ragtime
tunes, a sort of poetry which
leads me to a melancholic
happiness. To work in an office
is a refuge....
—MALCOLM COWLEY, 1923

Decorated with opaque Carrera Glass and stainless
steel, the lobby of McGraw-Hill is filled with
trademark Art Deco designs, including geometric
shapes, parallel lines, and rounded edges.

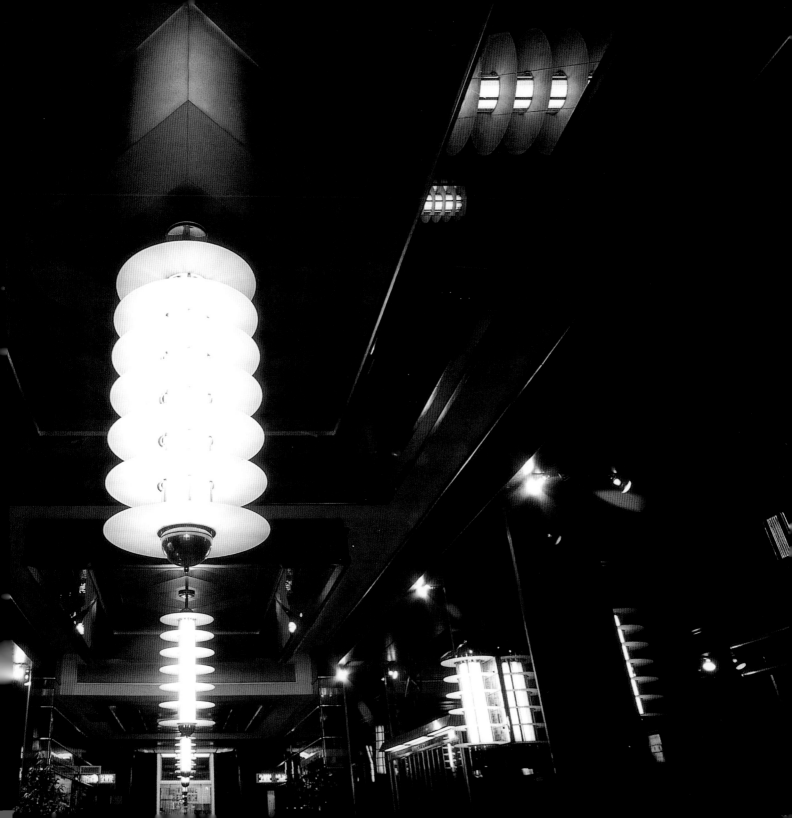

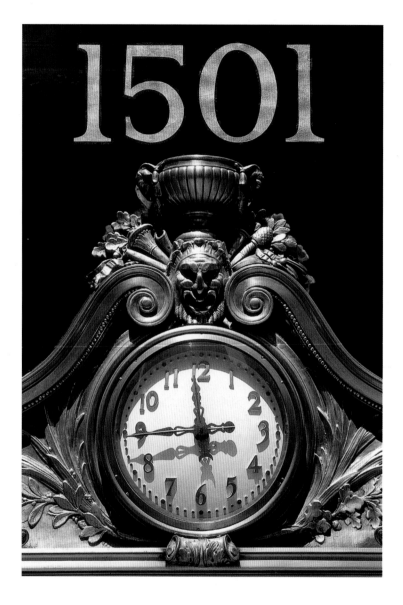

1501 Broadway was completed in 1926 for Paramount Pictures to house its offices and a cinema. Architects C. W. and George L. Rapp took inspiration from the Paris Opéra, with grandiose plans that included rich gold detail, clocks with faces that glowed at night, and an eighteen-foot glass globe.

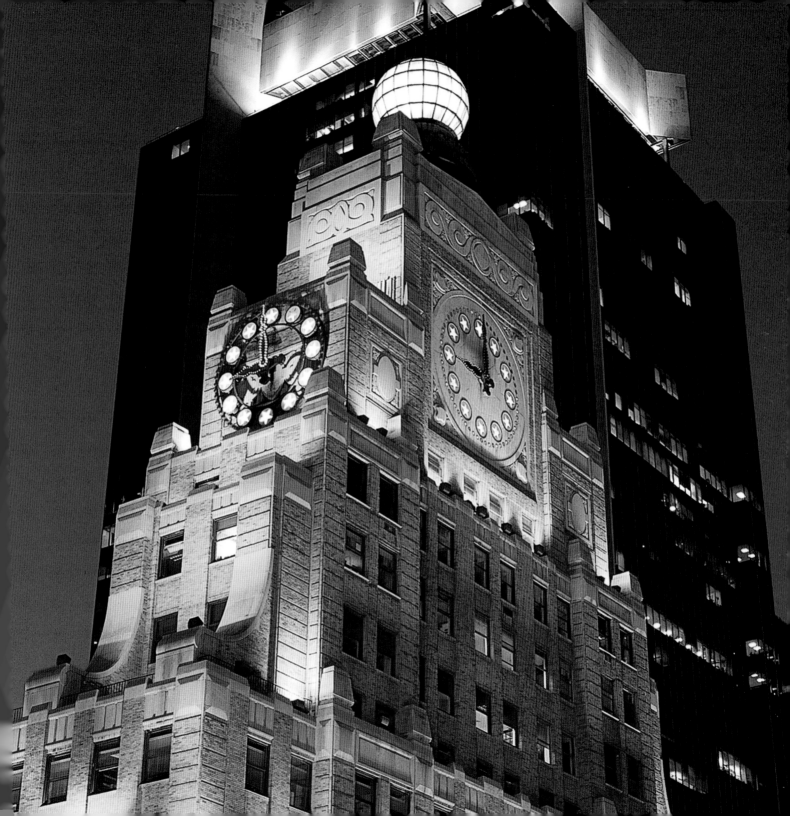

These skyscrapers, who belong to a brotherhood of giants, help each other to rise, to prop each other up, to soar until all sense of perspective disappears. You try to count the stories one by one, then your weary gaze starts to climb in tens.

—PAUL MORAND

OPPOSITE: Located at 40 West 40th Street, the American Standard Radiator Building (now the Bryant Hotel) features black brick with gold setbacks and terra-cotta work. Designing for the heating and plumbing manufacturer in 1924, architect Raymond Hood gave the small building a feeling of mass by using darker brick to reduce the contrast between the window openings and the solid wall.

OVERLEAF: In 1933 Bryant Park was slated for redevelopment through the Depression-era public works program, and a contest was held for the design. The winner, Lusby Simpson from Queens, created a classic garden with pathways leading to a central lawn, a large fountain, and these heroic art pieces. Implemented under Robert Moses and his staff, the park became the centerpiece of the neighborhood.

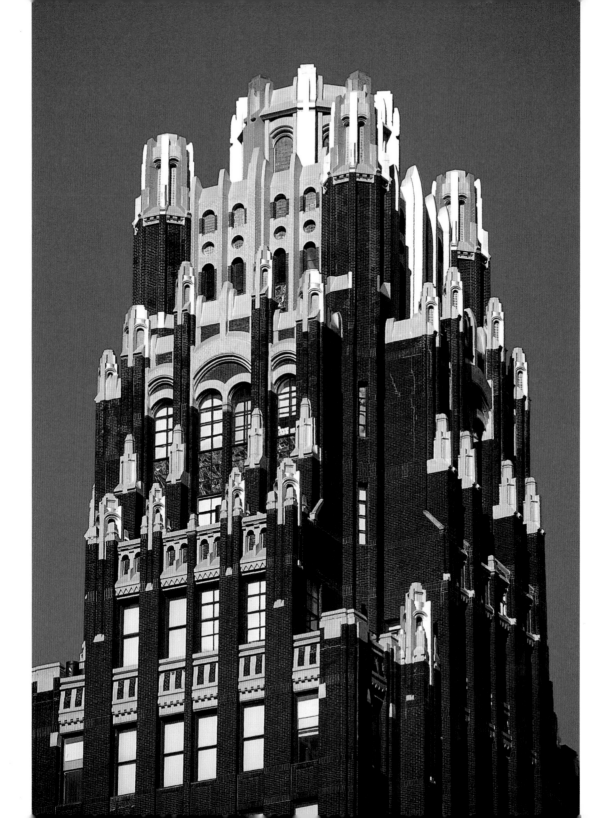

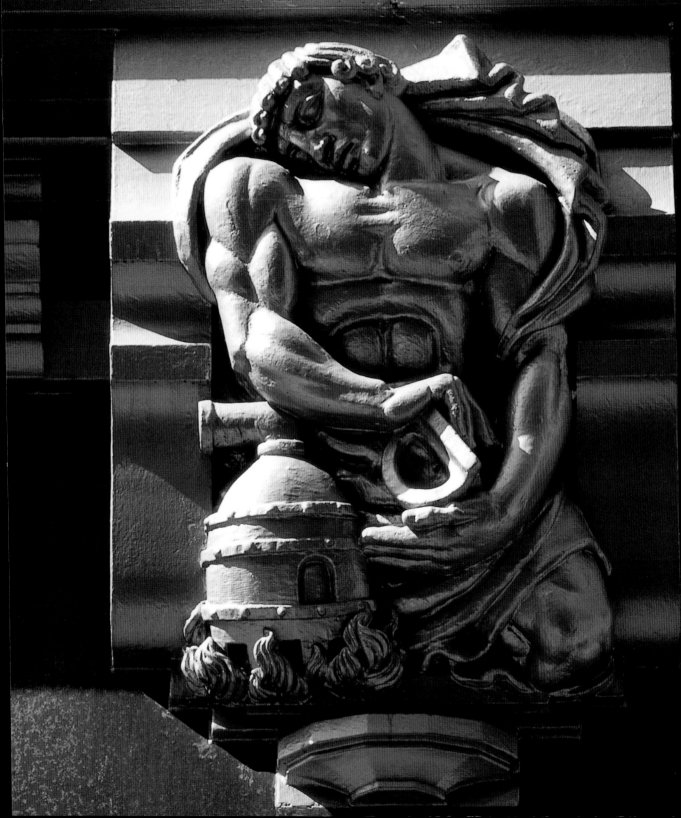

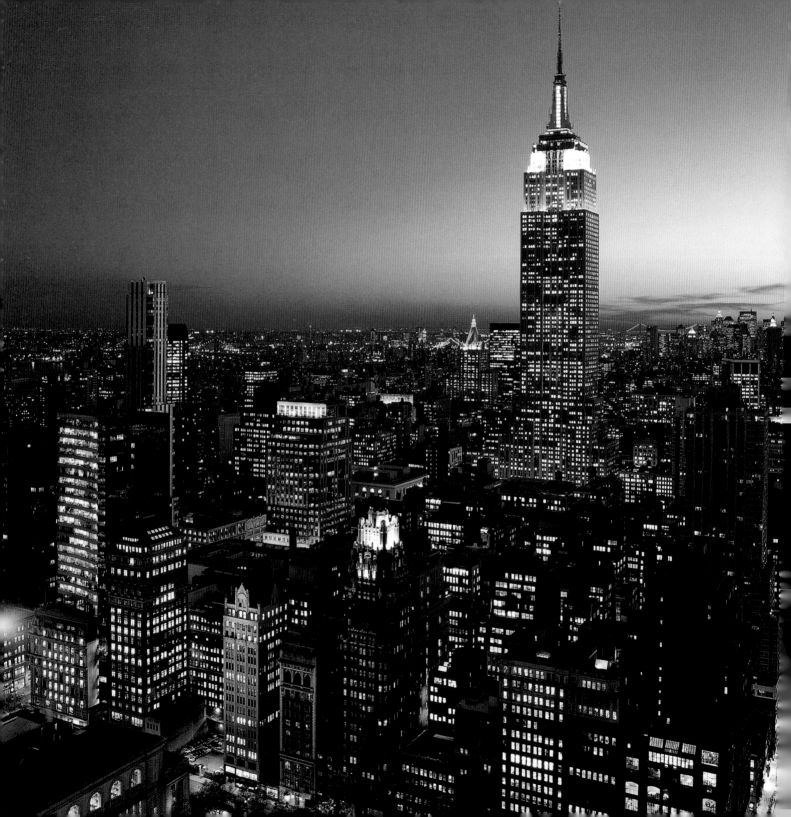

The astonishing thing [in New York City] is still the skyscrapers. . . . From far away and in the near distance they are enormously impressive: when one gets right under them they vanish and one regains one's normal size. . . . I wonder what it is in the New York air that enables me to sit up till all hours in the night in an atmosphere which in London would make a horse dizzy, but here merely clears the brain.

—JAMES AGATE, 1937

At night, the top of the Bryant Park Hotel (at bottom) is brightly lit and stands out even in an evening cityscape dominated, as usual, by the one and only Empire State Building.

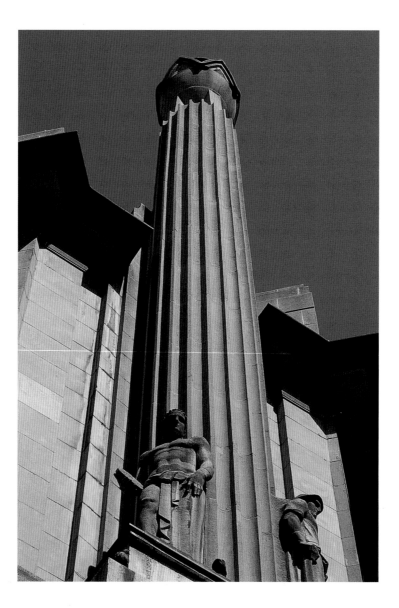

Using a combination of architectural styles that include Art Deco, the organizing concept behind Hearst's International Magazine Building was the idea that the offices housed there influenced the thought and education of the public. With that in mind, each of the columns is flanked by figures portraying music, commerce, art, and industry. Architect Joseph Urban completed the Hearst Building at 951–969 Eighth Avenue in 1929.

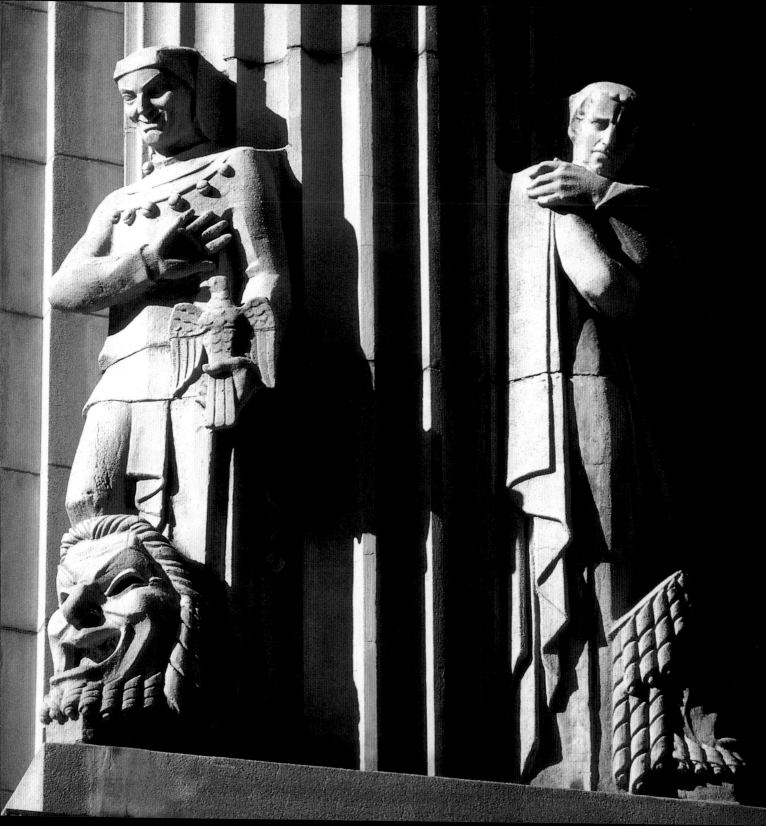

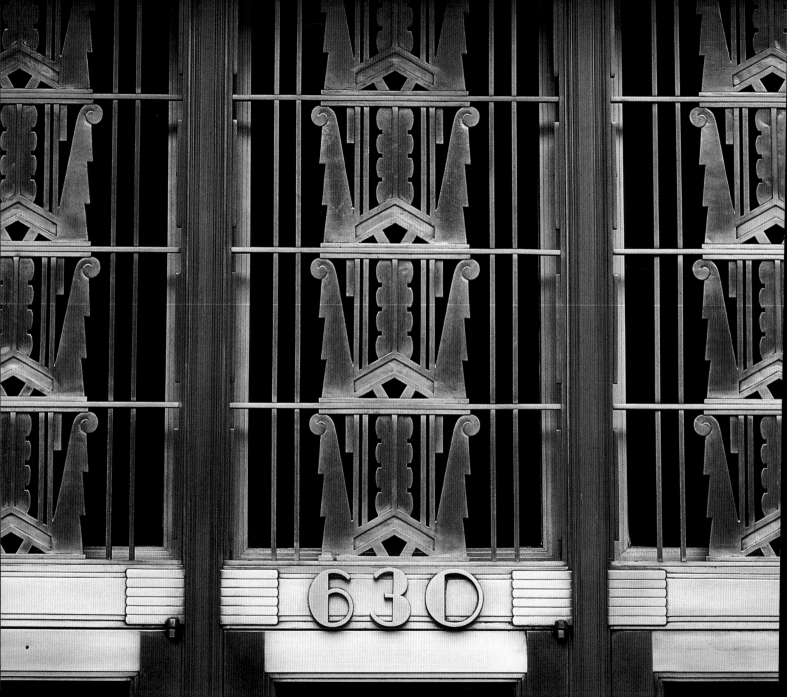

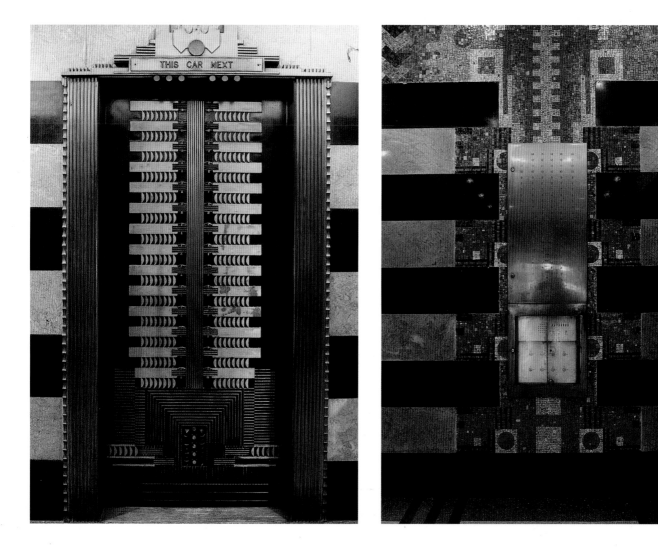

OPPOSITE: In the days when New York and Hollywood were equals in filmmaking, the Film Center was constructed to accommodate every aspect of production. Though the lobby of 630 Ninth Avenue is the building's true masterpiece, its exterior has a fine demonstration of the ornate metalwork created during the Art Deco period.

ABOVE: The lobby of the Film Center, designed by architect Ely Jacques Kahn in 1925, reflected textile patterns of the 1920s (right). This gold-and-black elevator in the lobby (left) is a Deco masterpiece, proving that parallel lines and a simple color palette can create a sense of the spectacular.

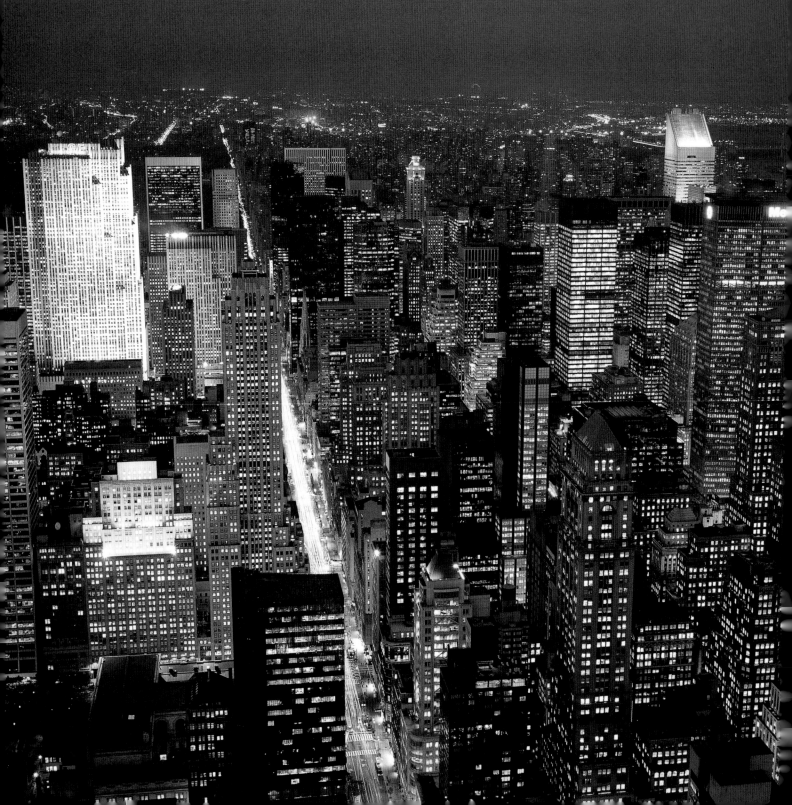

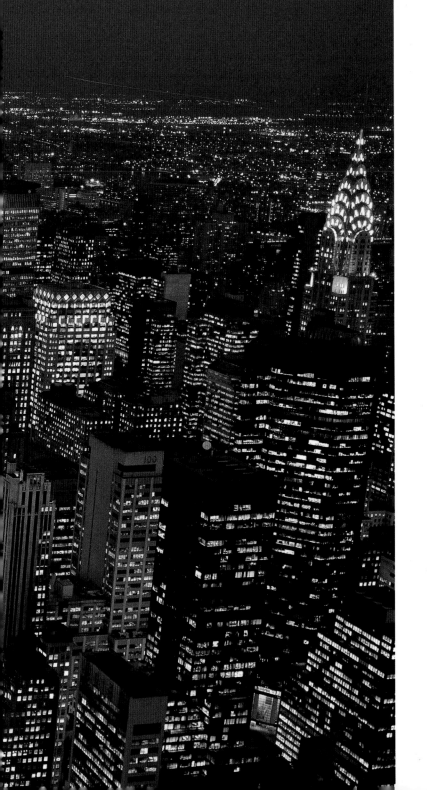

ew York is a vertical city, under the sign of the new times. It is a catastrophe with which a too hasty destiny has overwhelmed courageous and confident people, though a beautiful and worthy catastrophe. Nothing is lost. Faced with difficulties, New York falters. Still streaming with sweat from its exertions, wiping off its forehead, it sees what it has done and suddenly realizes: "Well, we didn't get it done properly. Let's start over again!" New York has such courage and enthusiasm that everything can be begun again, sent back to the building yard and made into something still greater, something mastered! These people are not on the point of going to sleep. In reality, the city is hardly more than twenty years old, that is the city which I am talking about, the city which is vertical and on the scale of the new times.

—LE CORBUSIER, 1936

An evening view of midtown Manhattan from atop the Empire State Building. At left is the brightly lit GE Building at Rockefeller Center; at right is the Chrysler Building.

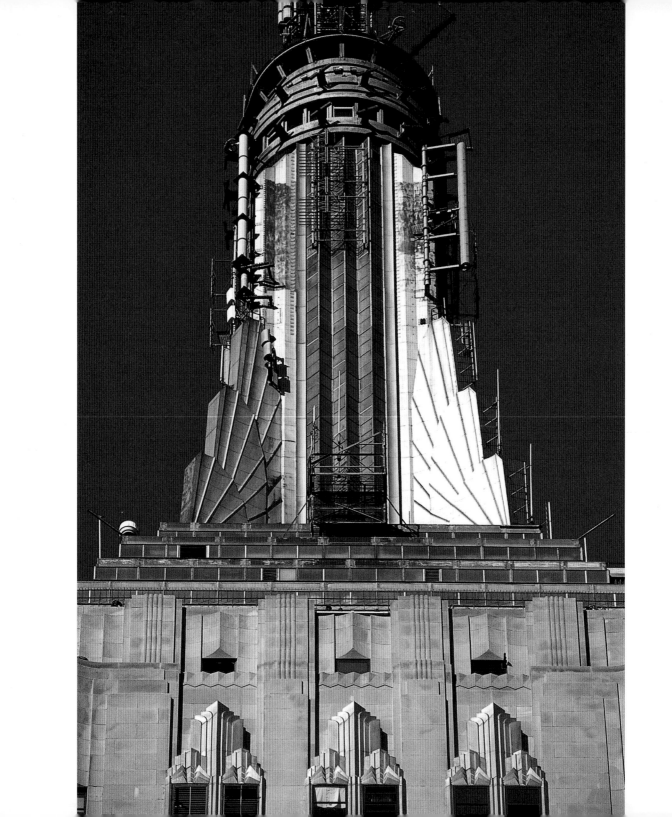

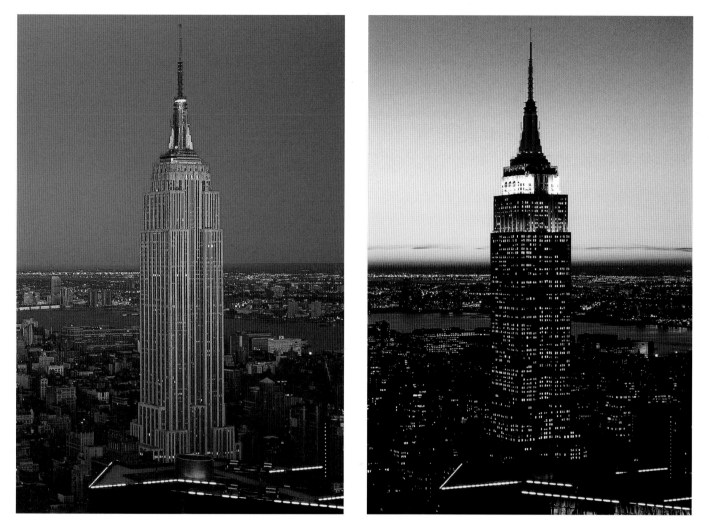

OPPOSITE: Completed in 1931, the world's tallest building project was spearheaded by John J. Raskob and former New York Governor Al Smith, along with architects Shreve, Lamb & Harmon. The top of the Empire State Building is a sheathed tower built to serve as a mooring mast for airships, even though the winds at 102 stories were too strong for the idea to be practical.

ABOVE: The majestic Empire State Building at dawn and dusk as seen from the Chrysler Building. Its top-floor floodlights have marked such events as Franklin Delano Roosevelt's presidential win in 1932, the Yankees' World Series victory in 1977, and the advent of the blue M&M, it starred worldwide in the film *King Kong*, and its observation deck offers arguably the greatest view in the city.

I like to think of all the city microcosms so nicely synchronized though unaware of one another: the worlds of the weight-lifters, yodelers, tugboat captains and sideshow barkers, of the book-dutchers, sparring partners, song pluggers, sporting girls and religious painters, of the dealers in rhesus monkeys and the bishops of churches that they establish themselves under the religious corporations law. It strengthens my hold on reality to know when I awake with a brandy headache in my house which is nine blocks due south of the Chrysler Building and four blocks due east of the Empire State, that Eddie Arcaro, the jockey, is galloping a horse around the track at Belmont while Ollie Thomas, a colored clocker of my acquaintance, is holding a watch on him. I can be sure that Kit Coates, at the Aquarium, is worrying over the liverish deportment of a new tropical fish, that presently Whitey will be laying out the gloves and headguards for the fighters he trains at Stillman's gymnasium, while Miss Ira, the Harlem modiste, will be trying to talk a dark-complexioned girl out of buying herself an orange turban and Hymie the Tummler ruminates a plan for opening a new night club. It would be easier to predicate the existence of God on such recurrences than on the cracking of ice in ponds, the peeping of spring peepers in their peeperies and the shy green sprigs of poison ivy so well advertised by writer like Thoreau.

—A.J. LIEBLING, 1938

Despite lacking classic exterior Art Deco adornments or geometric designs, the Empire State Building is still firmly grounded in the period that embraced all things extravagant. The lobby of the Empire State Building at 350 Fifth Avenue features a heavenly depiction of itself, created out of metal and marble.

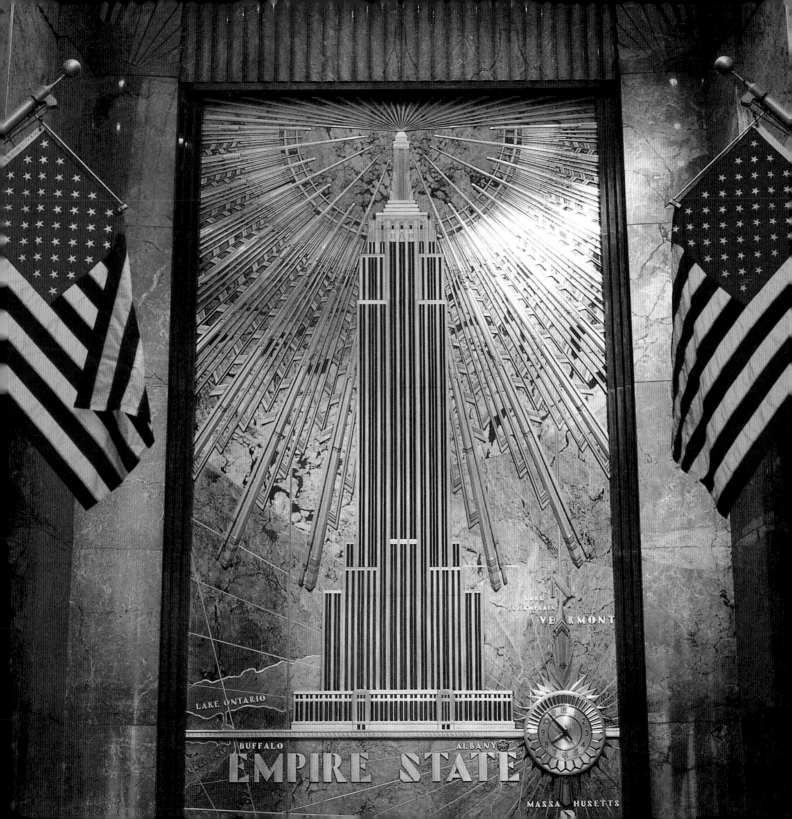

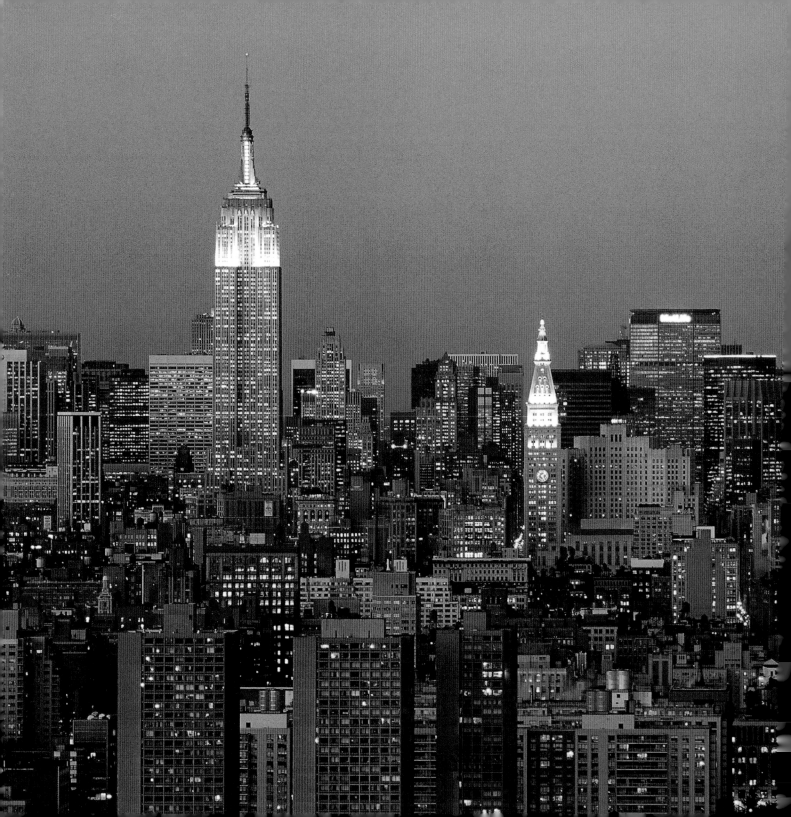

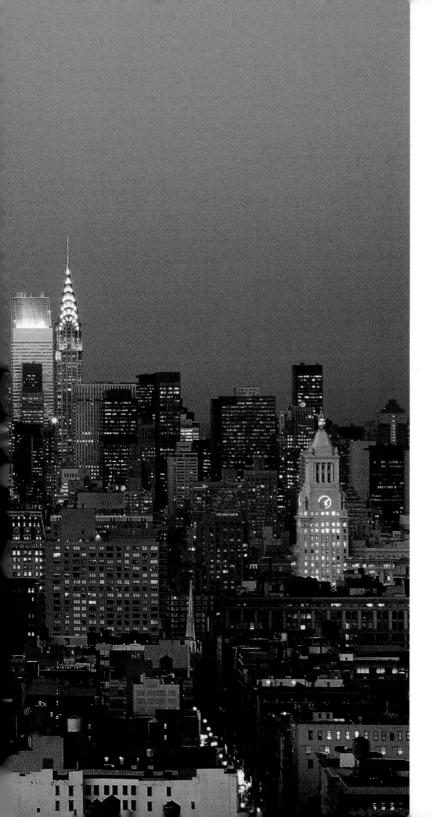

I s "New York" the most beautiful city in the world? It is not far from it. No urban nights are like the nights there. I have looked down across the city from high windows. It is then that the great buildings lose reality and take on magical powers.

—EZRA POUND

83

The Manhattan skyline at dusk is highlighted by the buildings of the Art Deco period with their emphasis on the vertical and lavishly decorative motifs. At left is the Empire State Building, with its famous spire and brightly lit top floors. To the right, the skyline is punctuated by the Chrysler Building with its signature Nirosta steel sunburst. At the far right, the Con Ed Building keeps time with one if its four large-faced clocks.

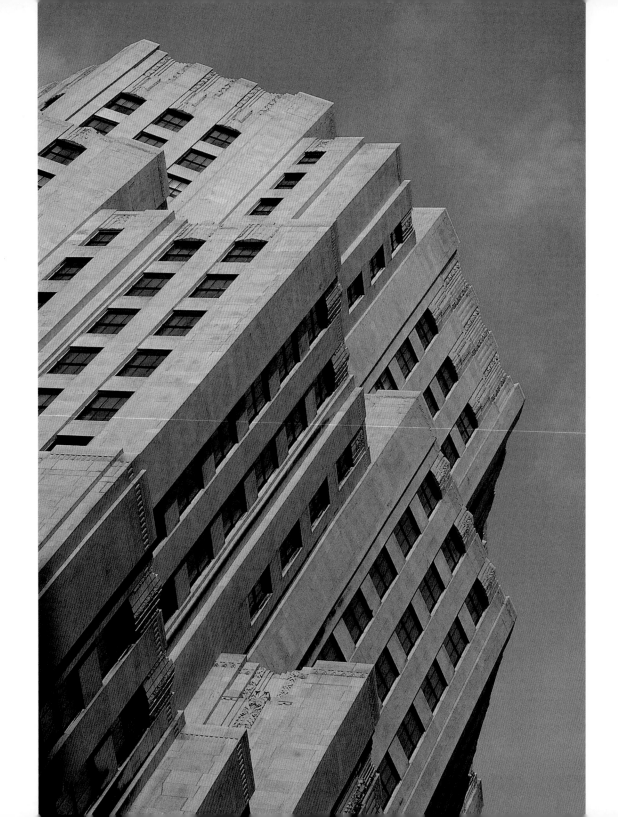

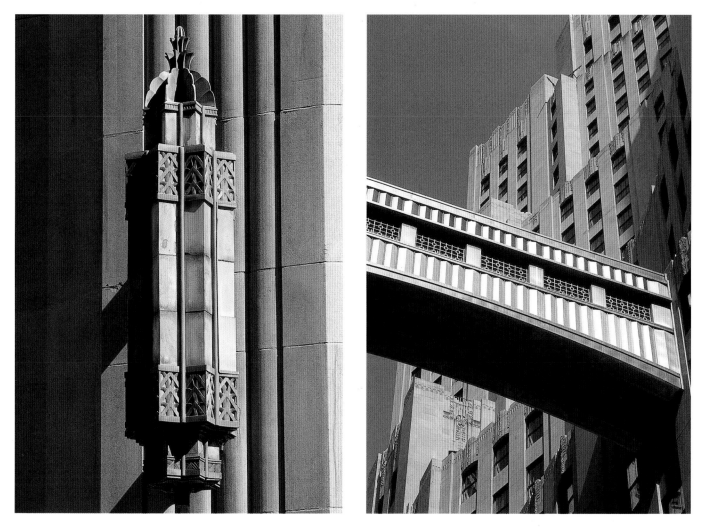

OPPOSITE: When the Metropolitan Life Insurance Company needed more space in 1929, the North Building was conceived and designed by architects Harvey Wiley Corbett & D. Everett Waid. The tweny-nine story building was constructed in four pieces over nearly seventeen years.

ABOVE: On the left, a large lantern brightens the heavy limestone exterior; on the right, an ornately decorated walkway connects the North Building at 11 Madison with the rest of the MetLife complex.

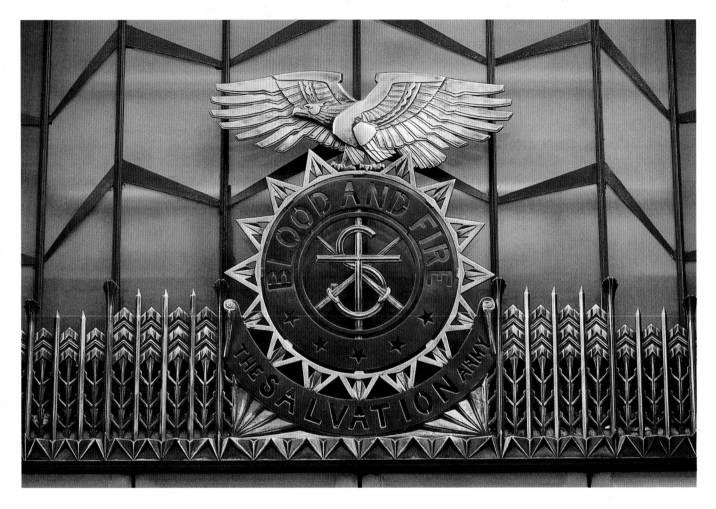

ABOVE: Located at 120 West 14th Street, the Salvation Army Headquarters was built under the leadership of Evangeline Booth, commander in chief of the American Corps and daughter of the army's founder. Architects Voorhees, Gmelin & Walker completed the project in 1930 with very few ornaments except for this golden Salvation Army symbol and churchlike gates under the main archway.

OPPOSITE: At the corner of 34th and Madison lies a small treasure by French ironworker Edgar Brandt. Ornate black leaves weave behind a golden fountain, on the classic Deco address plate of the Cheney Brothers' store at 181 Madison.

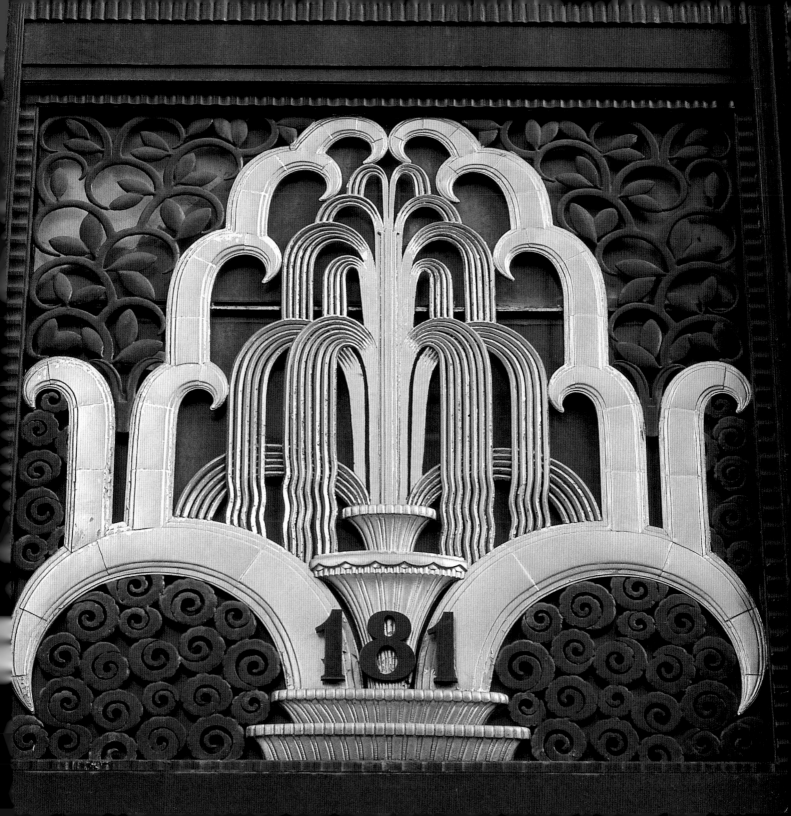

N ew York looks as ever: stiff, machine-made, and against nature. It is so mechanical there is not the sense of death.

—D.H. LAWRENCE, 1924

88

Bold geometric patterns adorn the facade of 235 East 22nd Street. Architects George and Edward Blum designed this building in 1932 with teal, blue, and black lines lighting up the otherwise all-brick exterior.

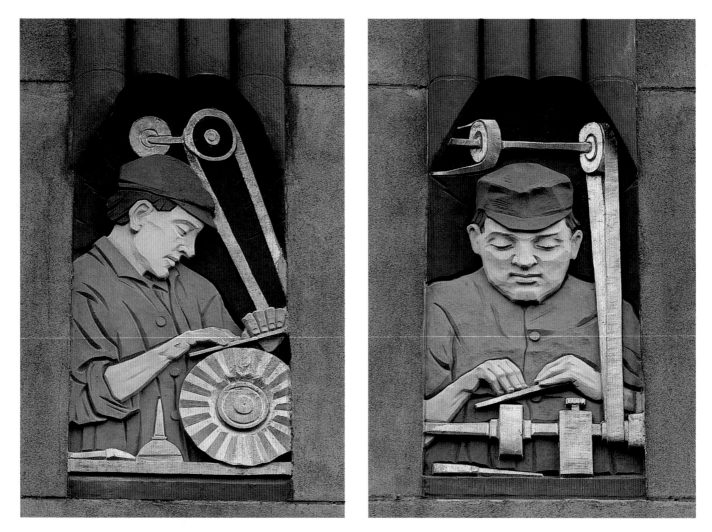

90

OPPOSITE AND ABOVE: Built between 1928 and 1930, the Green Building at 100 Sixth Avenue was designed by Ely Jacques Kahn. The prominent exterior feature is the bas-relief of workers placed above the door on the second floor.

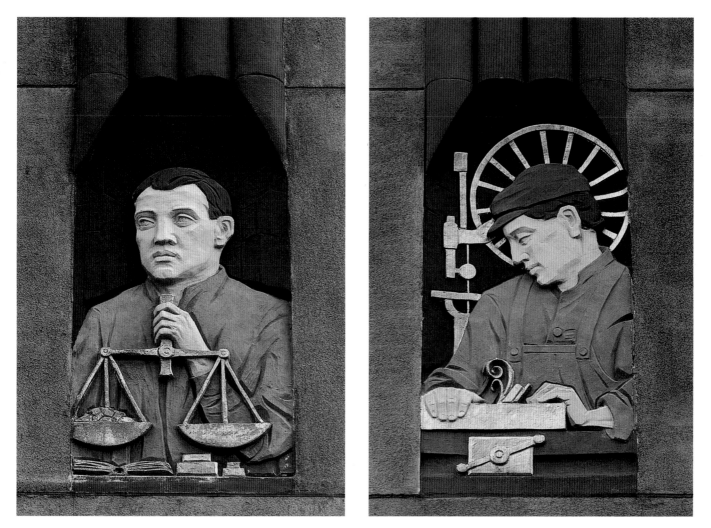

. . . As the toiler must live in the city's belly, so I was compelled to live in its disordered mind.

—F. SCOTT FITZGERALD, 1939

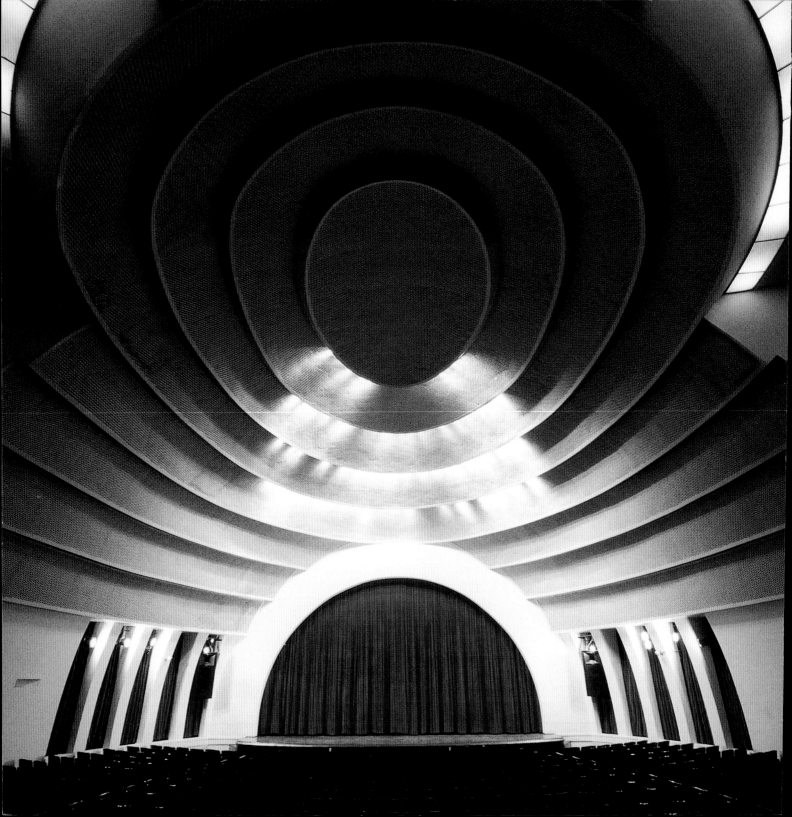

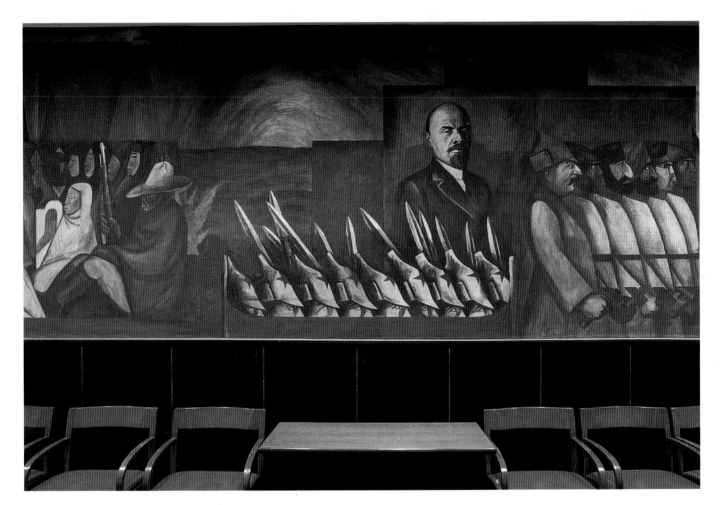

OPPOSITE: Initially criticized for its irrationality, the New School's Tishman Auditorium is now recognized as one of the few great works left from architect Joseph Urban. Built at 66 West 12th Street in 1930, the auditorium features an unusual egg shape with an arched proscenium. The ceiling was painted in nine shades of gray and accented with red curtains and beams. It was Urban's last design before his death in 1933.

ABOVE: To accompany Joseph Urban's new auditorium, José Clemente Orozco offered his services as a muralist. He was allowed complete control over his style and subjects, which resulted in five frescoes that focused on "dynamic symmetry." These two frescoes are titled *The Table of Brotherhood* and *Carrillo Puerto and Lenin and the Bolshevik Revolution.*

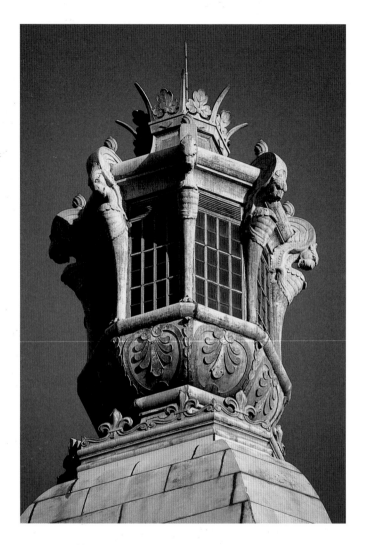

ABOVE: Referred to as "the Tower of Light," this addition to the Con Ed Building was begun in 1926 as a memorial to the company's employees who died in World War I. Architects Warren & Westmore designed the twenty-six-story tower, seen here at 4 Irving Place, to be a landmark. They faced it with limestone and set it back at the top to create a small temple, crowned by a thirty-eight foot-high bronze lantern.

OPPOSITE: Four clock faces and four corner urns sit twenty-one stories up on the Con Ed Tower. Though not the tallest building in New York, it was surrounded by smaller structures that guaranteed the tower would be a strong visual symbol for the country's leading utility company.

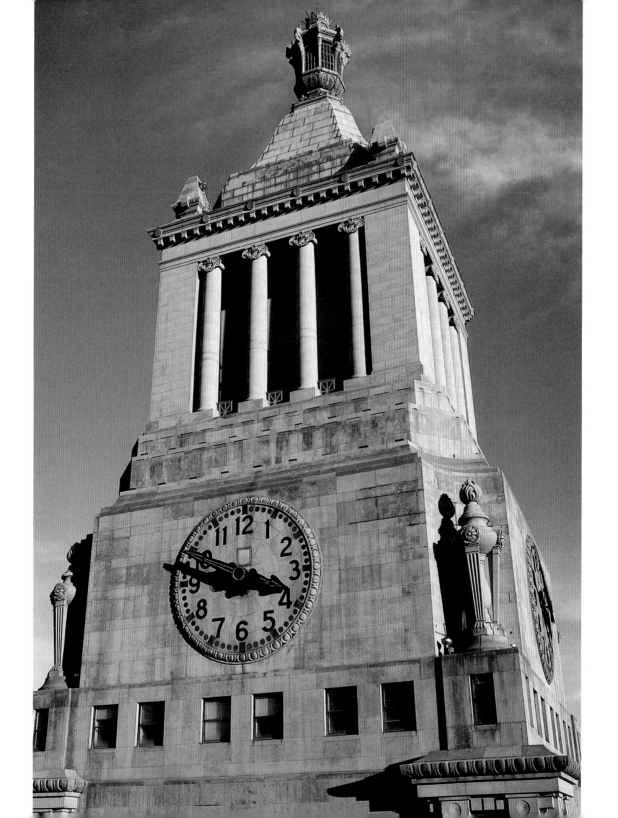

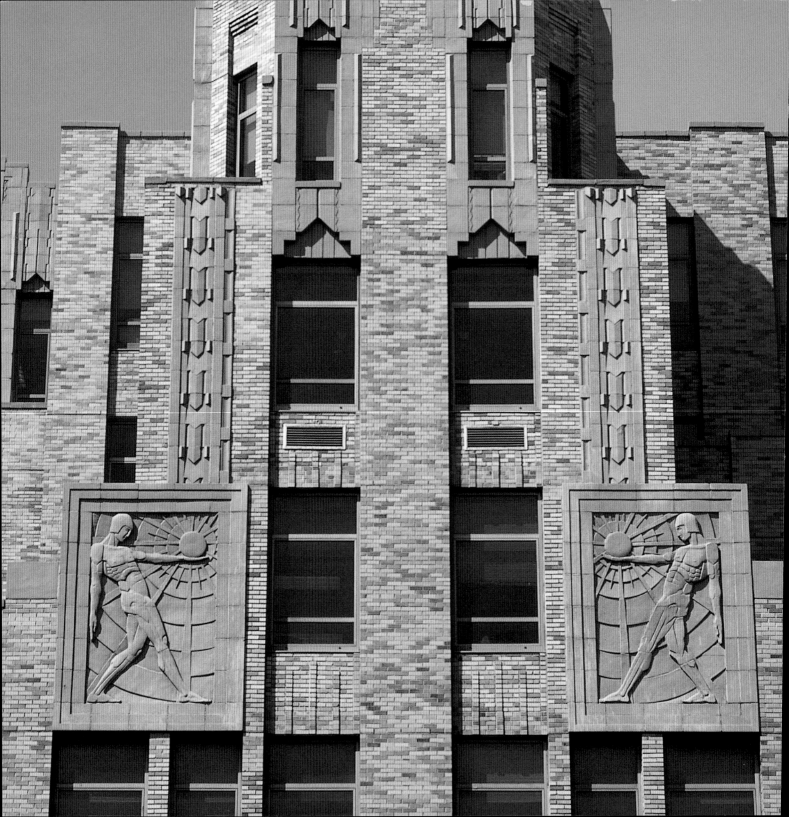

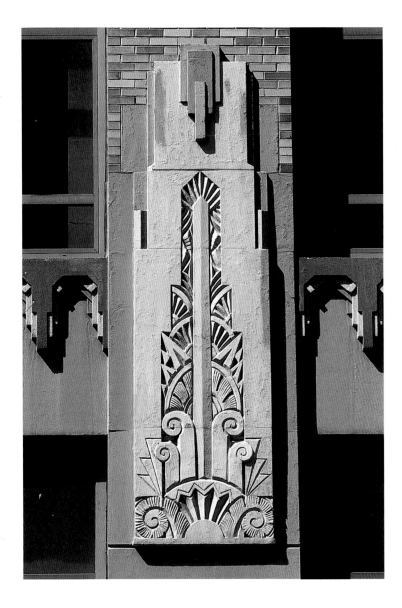

The exterior of 345 Hudson Street has purely decorative pieces (above)
with curving geometric shapes as well as the traditional Art Deco heroic figures (left).
This 17-story industrial loft building was constructed in 1931.

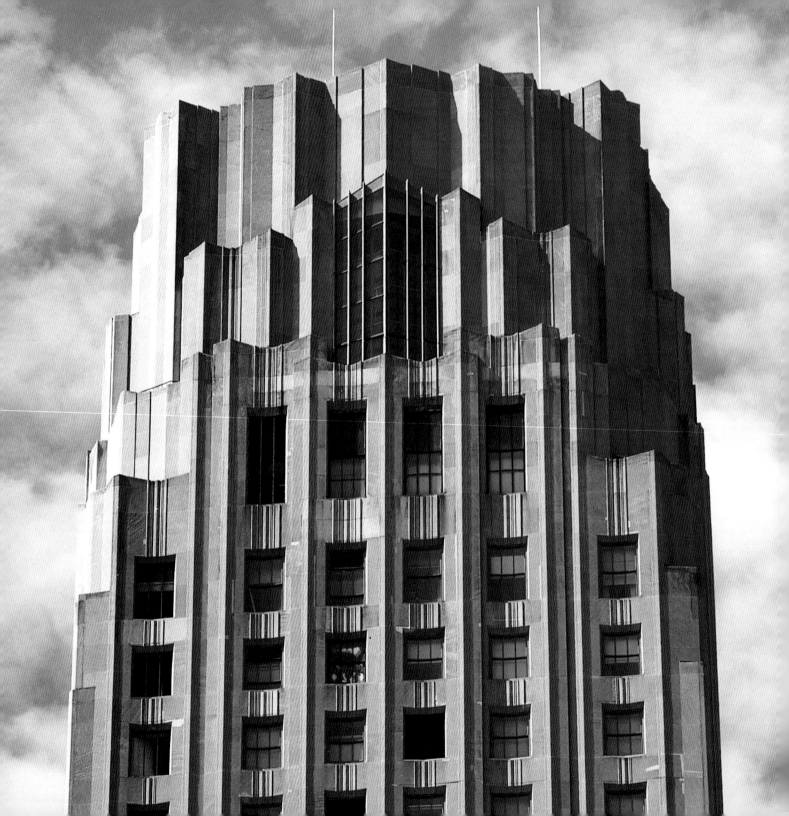

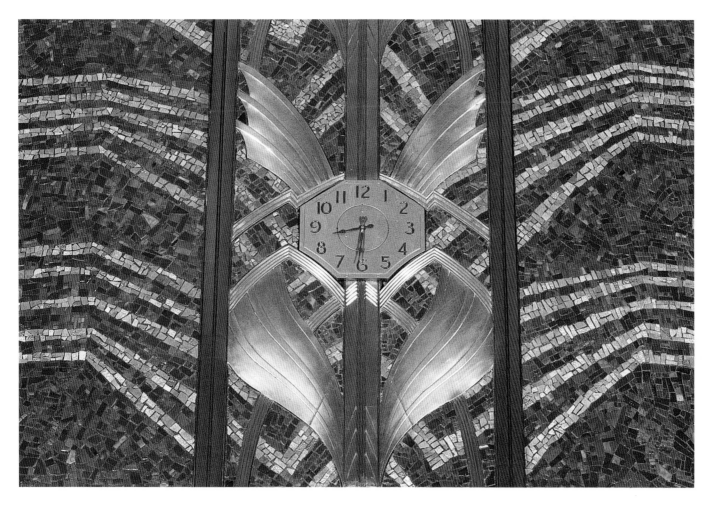

OPPOSITE: The top of the Irving Trust Building, which was completed in 1932, at 1 Wall Street.

ABOVE: Perhaps the most impressive glass mosaic work in New York can be found inside the building. The prominence and wealth of this upper-class financial institution was expressed through this mesmerizing piece created by architect Ralph Walker and artist Hildreth Meiere.

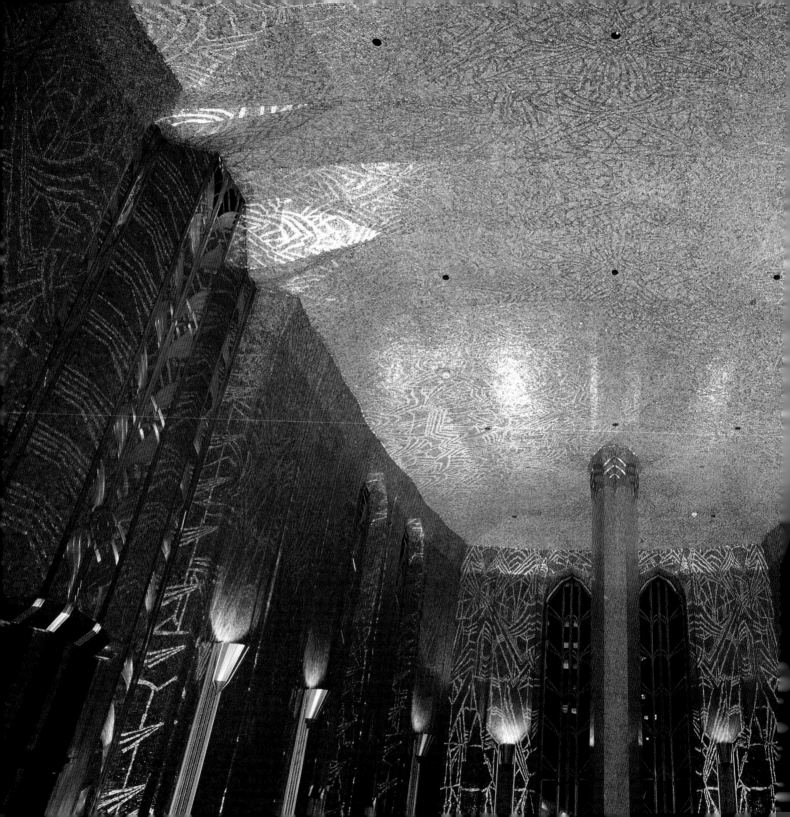

I began to like New York, the racy, adventurous feel of it at night, and the satisfaction that the constant flicker of men and women and machines gives to the restless eye. I liked to walk up Fifth Avenue and pick out romantic women from the crowd and imagine that in a few minutes I was going to enter into their lives, and no one would ever know or disapprove. Sometimes, in my mind, I followed them to their apartments on the corners of hidden streets, and they turned and smiled back at me before they faded through a door into warm darkness.

—F. SCOTT FITZGERALD, 1925

101

The glowing tiles of Meiere's mosaic shift from red to gold as they approach the ceiling, giving the illusion of a bright sun beaming down on the Reception Hall.

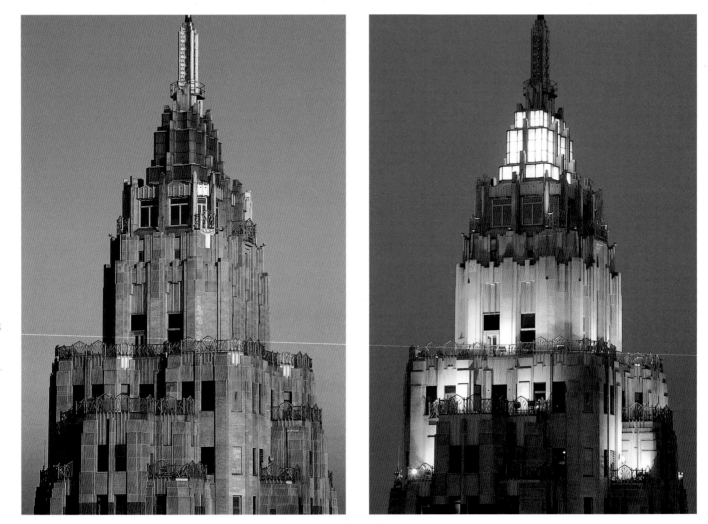

ABOVE: Now known as the American International Building, 70 Pine Street was built in 1932 for
the Cities Service Company. The last skyscraper to be built in the financial district before World War II,
this Art Deco gem by Clinton & Russell and Holton & George once featured double-decker elevators
and still boasts one of the best views around from its glass observatory at its summit.

OPPOSITE: Ornate silver flora and fauna designs decorate the exterior at 70 Pine.

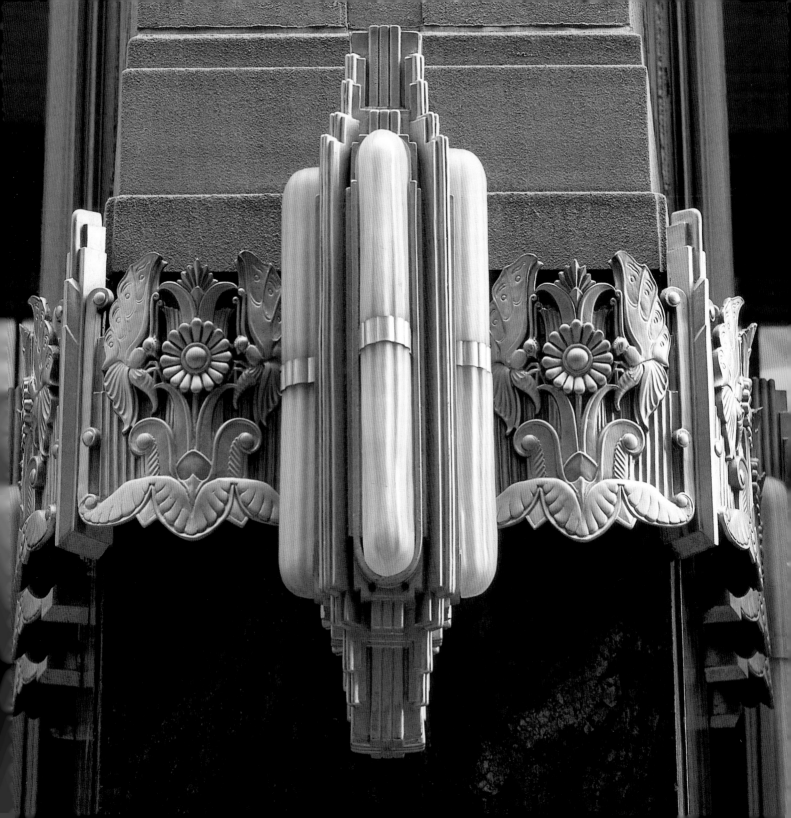

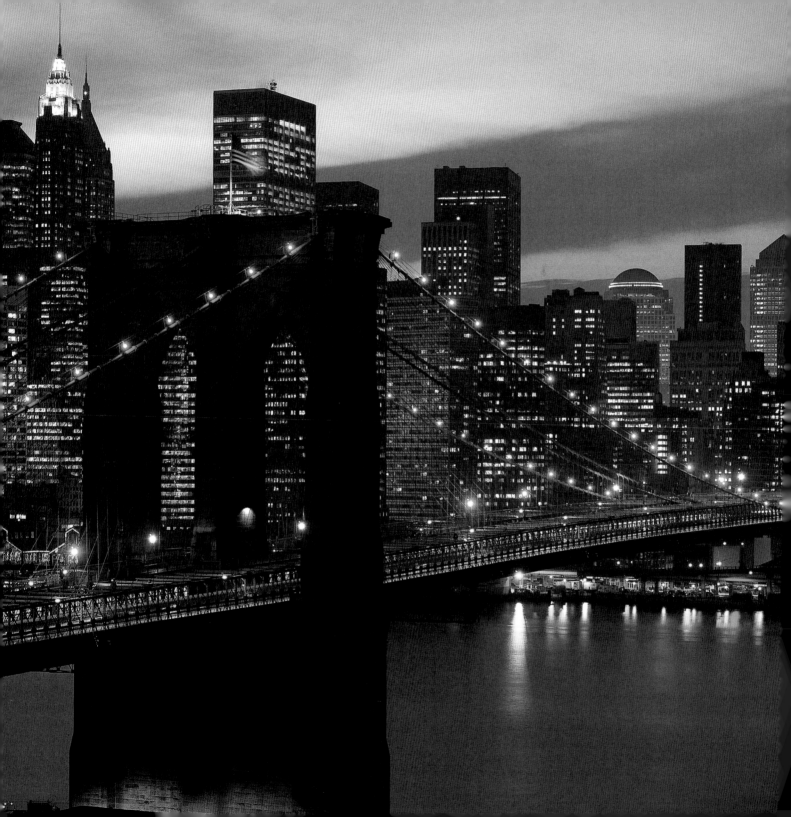

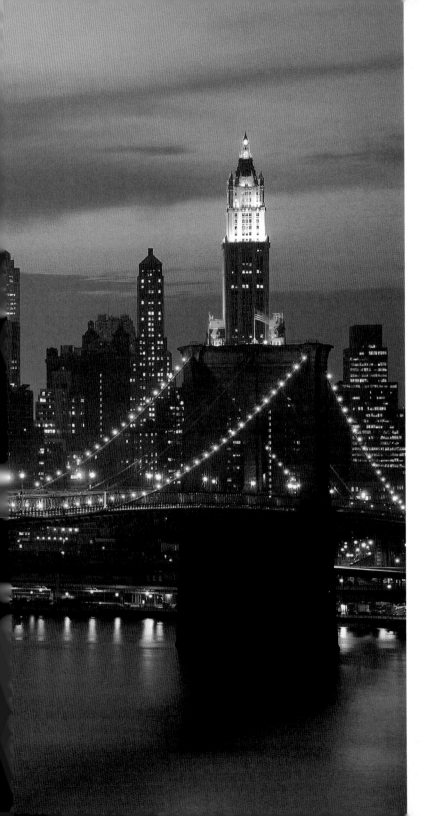

At night...the streets become rhythmical perspectives of glowing dotted lines, reflections hung upon them in the streets as the wisteria hangs its violet racemes on its trellis. The buildings are shimmering verticality, a gossamer veil, a festive scene-prop hanging there against the black sky to dazzle, entertain, amaze.

—FRANK LLOYD WRIGHT

105

Surrounded by modern glass and steel buildings, the Cities Service Building still punctuates the lower Manhattan skyline, particularly at night with its brightly lit classic Art Deco pyramid top and striking spire.

ABOVE AND OVERLEAF: Erected in 1931 by Cross & Cross, the City Bank Farmers Trust Company Building features four sculpted heads overlooking the street. At the entrance are several bronzed doors with images depicting various forms of transportation. Located at 20 Exchange Place, the building once had a covered walkway that connected it to 55 Wall Street.

OPPOSITE: Decorative metal work above the entrance of the City Bank Farmers Trust Company Building.

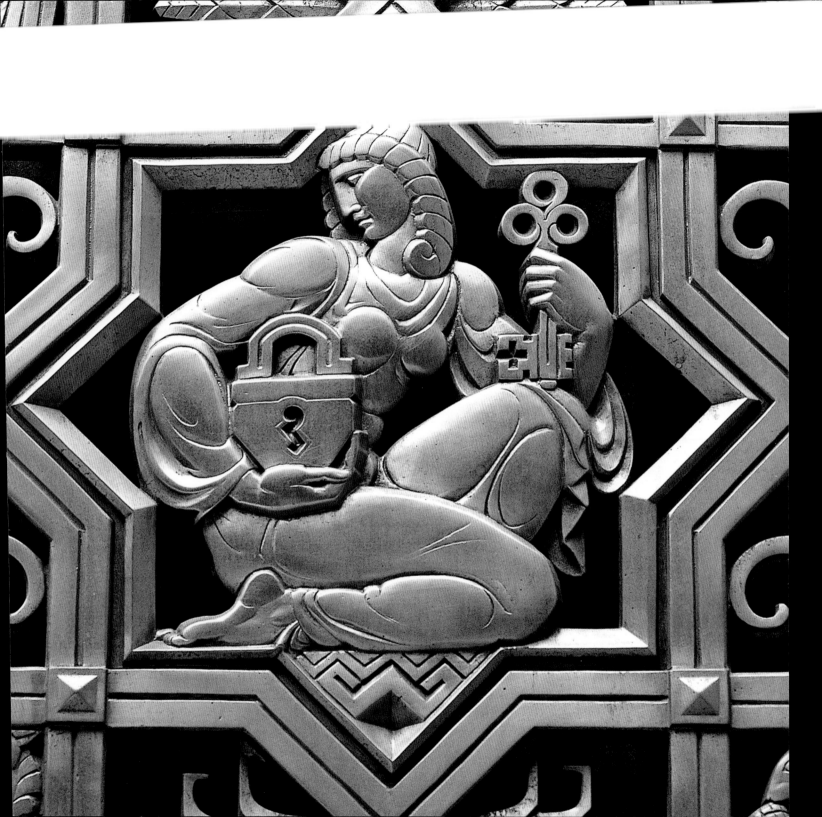

Sometimes, from beyond the skyscrapers, the cry of a tugboat finds you in your insomnia, and you remember that this desert of iron and cement is an island.

—ALBERT CAMUS

At the entrance of the City Bank Farmers Trust Company Building are several bronzed doors with images depicting various forms of transportation.

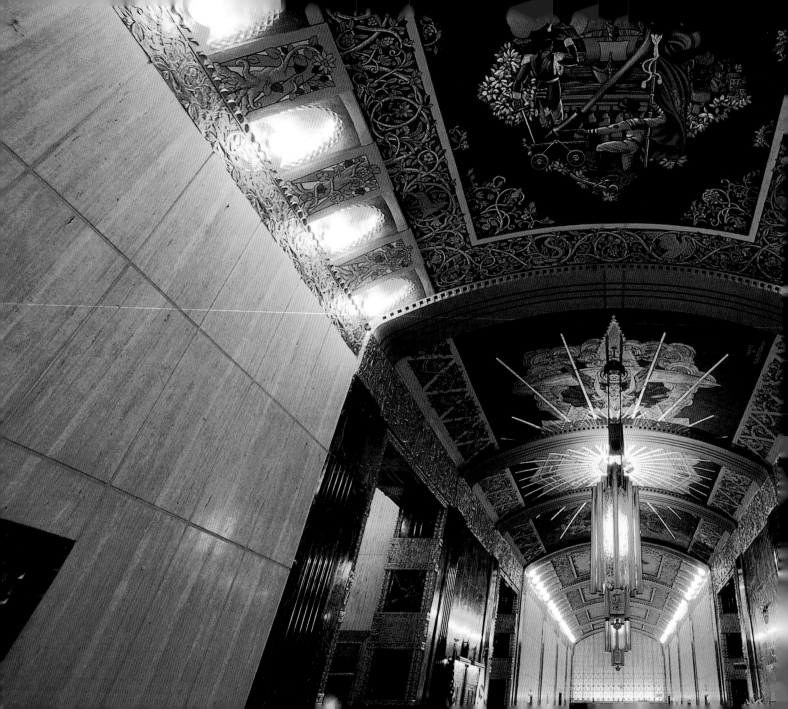

The great big city's a wondrous toy
Just made for a girl and boy
We'll turn Manhattan
Into an isle of joy.

—LORENZO HART, 1925

The Barclay-Vesey Building at 140 West Street between Barclay and Vesey was New York's first Art Deco skyscraper. Completed in 1927 by Ralph Walker for the New York Telephone Company, the two-hundred-plus-foot lobby was a vaulted arcade extensively decorated with ceiling frescoes by Hugo R. B. Newman. His painting depicts the history of communication, ending with the "candlestick" telephone.

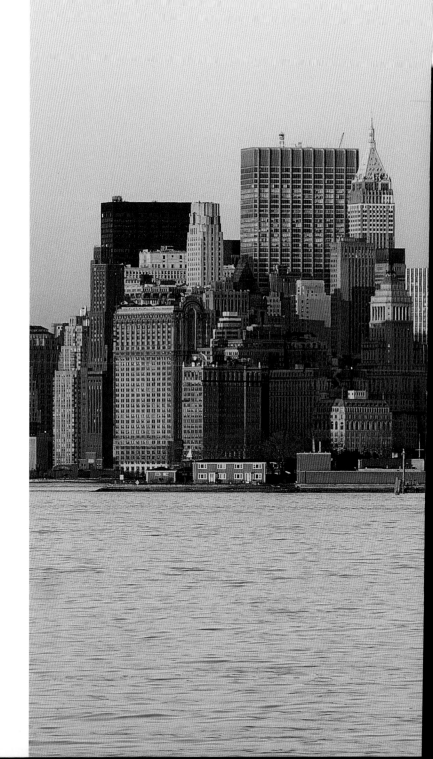

And suddenly as I looked back
at the skyscrapers of lower New York
a queer fancy sprang into my head.
They reminded me quite irresistibly
of piled-up packing-cases outside a
warehouse. I was amazed I had not
seen the resemblance before. I could
really have believed for a moment
that that was what they were, and that
presently out of these would come the
real thing, palaces and noble places,
free, high circumstances, and space
and leisure, light and fine living for
the sons of men.

—H.G. WELLS

A view of lower Manhattan illustrates how Art Deco
has influenced the city's skyline with slender and
stone-based structures. Distinctive from the modern
buildings around them, the Irving Trust Building on the
left rises with small, step-like recessions in the center,
with the copper pyramid roof stands 40 Wall Street,
and rivaling its steeple is the Cities Services spire,
hidden behind several other structures including, the
limestone City Bank Farmers Trust building.

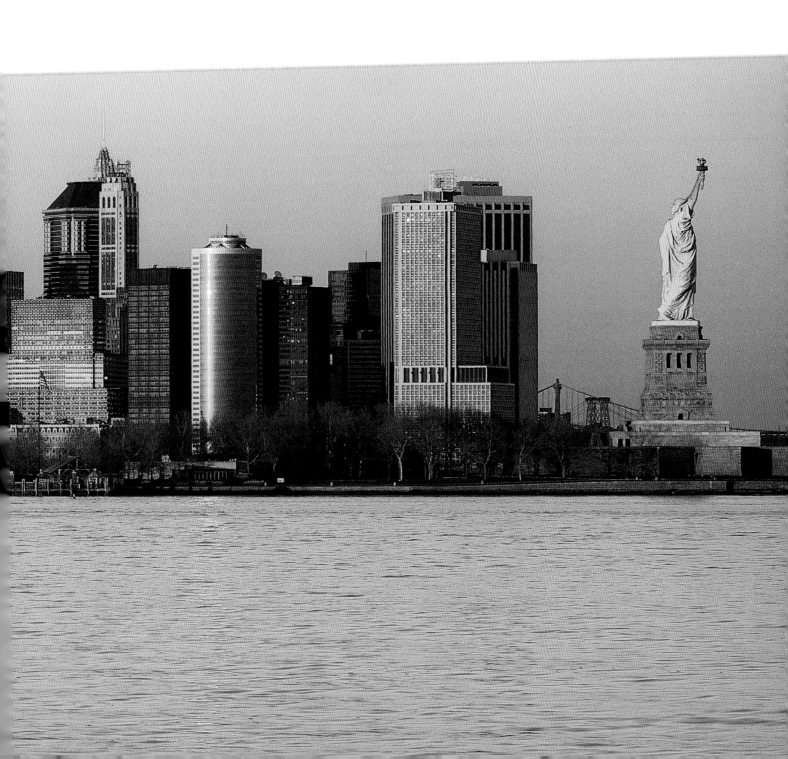

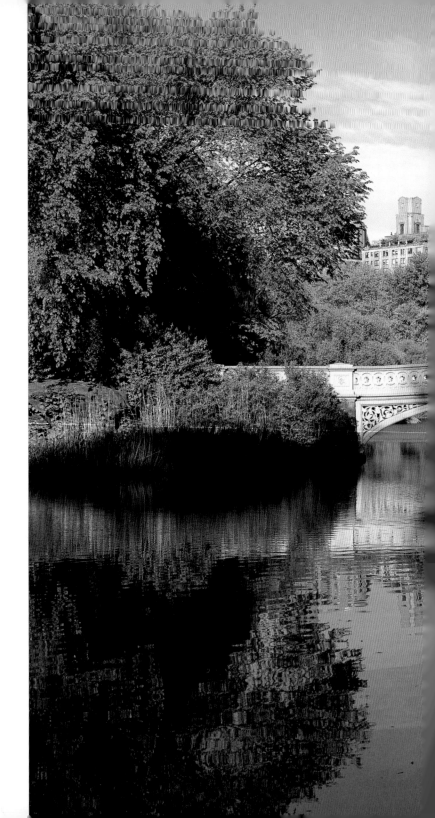

So I can say with impunity
That New York is a city of opportunity.
It also has many fine theaters and hotels,
And a lot of taxis, buses, subways and els,
Best of all, if you don't show up at the
 office or a tea nobody will bother
 their head
They will just think you are dead.
That's why I really think New York
 is exquisite.
It isn't all right just for a visit
But by God's Grace
I'd live in it and like it even better if
 you gave me the place.

—OGDEN NASH, 1931

During a construction boom in the late 1920s and
early 1930s along Central Park West, several Art
Deco structures were created, including four twin-
towered apartment buildings. From the serene Bow
Bridge in the park, one can view the magnificent
limestone towers of the Century to the right.

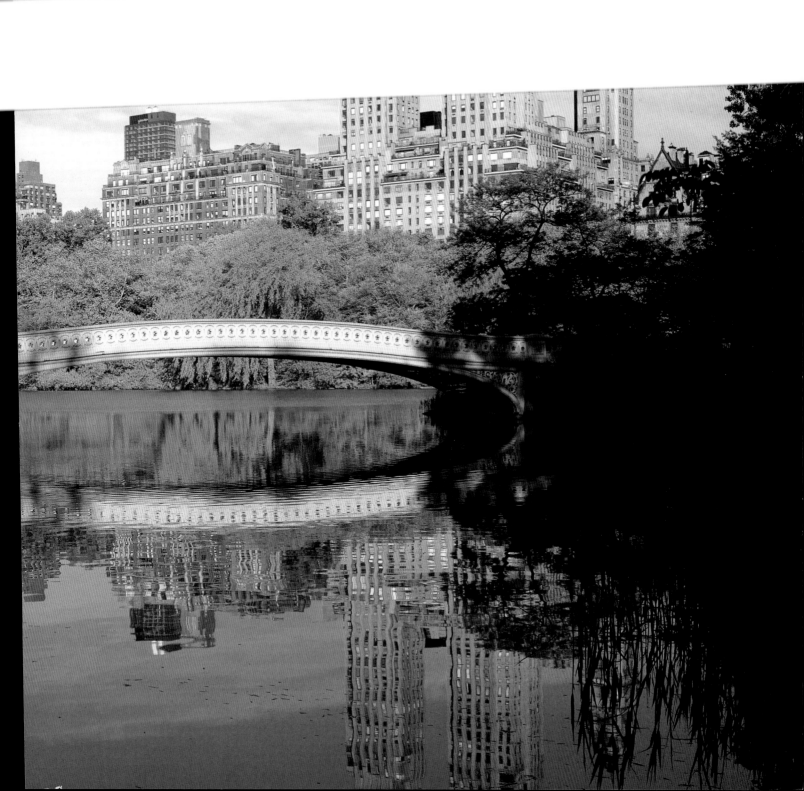

ABOVE: Detail from the lobby of the Century.

RIGHT: Offering fifty-two different apartment
types including an eleven-room duplex, the Century
Apartments was designed for the developer Irwin
Chanin by Jacques Delamarre and completed in 1931.
Located at 25 Central Park West, its most significant
design element is the top, including a narrow setback
and perpendicular lines cut into the building.

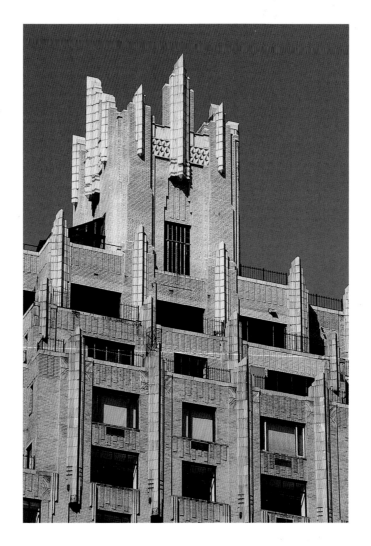

ABOVE: Schwartz & Gross departed from tradition when they created 55 Central Park West in 1930. Using coloring as a focal point, they started the base of the building in a darker red and slowly shifted to a pale tan at the top, giving the illusion that the sun was always shining directly on it.

OPPOSITE: Located at 115 Central Park West, the Majestic was intended to be an apartment building that reveled in Old World luxury living, but halfway through construction the stock market crashed. Architect Jacques Delamarre and developer Irwin Chanin changed the plan for the building to a more simplified Art Deco style. With its curved wings and wraparound windows, the 1930 Majestic brought a more streamlined and modernist look to New York apartment buildings.

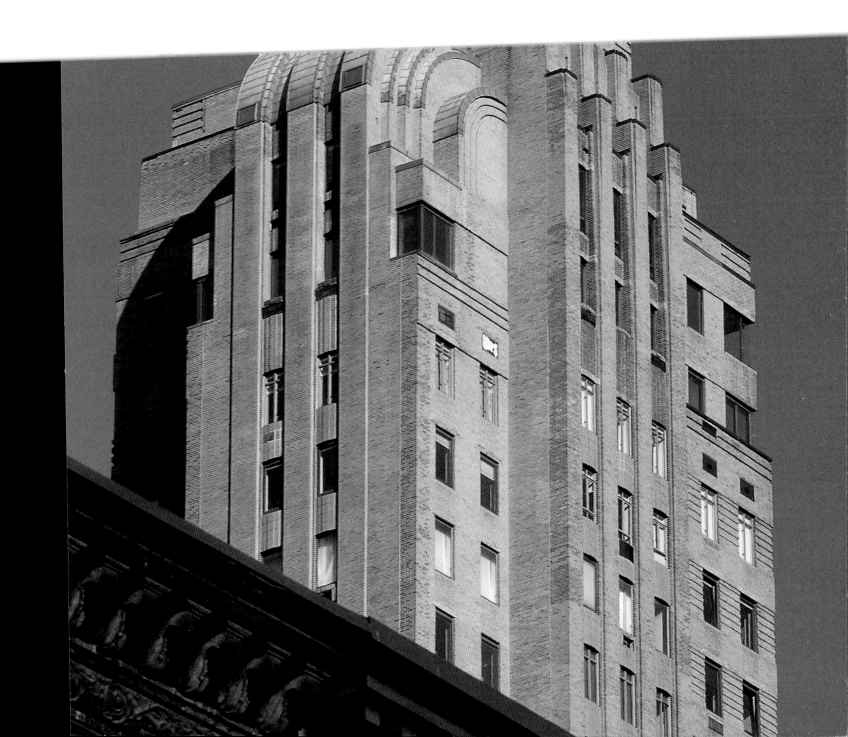

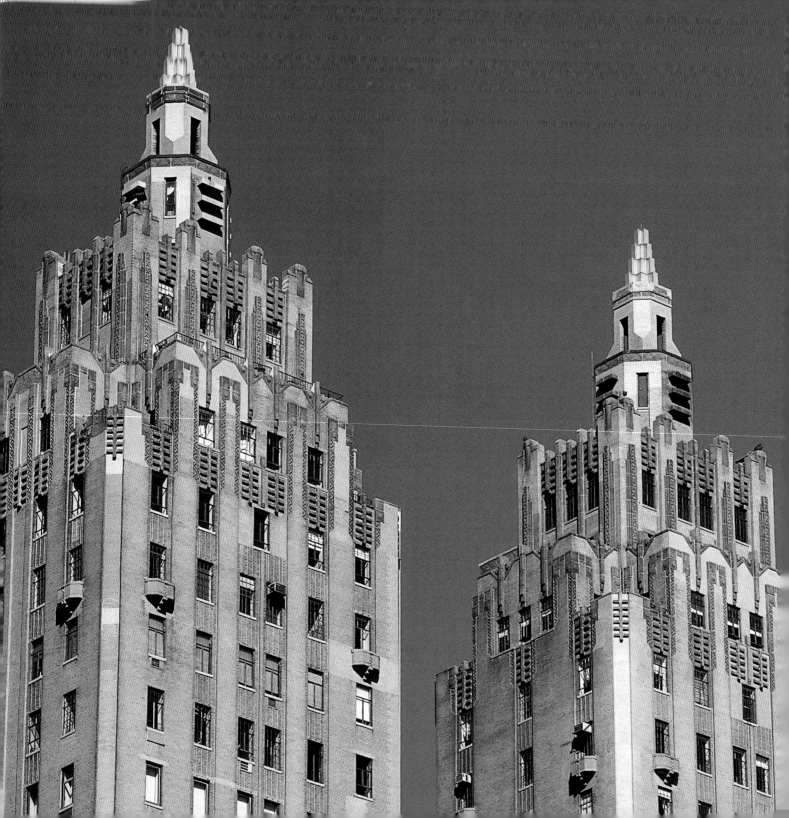

OPPOSITE: The futuristic sculpting and decisive setbacks of the twenty-nine-story El Dorado Apartment
Building, built in 1931, culminate at two belfries, designed to be lighted with red beams at night.
Guests such as Marilyn Monroe and Groucho Marx enjoyed the building's prime location at 300 Central Park
West and the stylish vision of its architects, Emery Roth and Margaret Holder.

ABOVE: A detail from the archway that leads to the luxurious lobby entrance of the El Dorado.

First New York was a sort of
provincial capital, bigger and richer
than Manchester or Marseilles, but
not much different in its essential
spirit. Then, after the war, it became
one among half a dozen world cities.
Today it has the appearance of
standing alone, as the center of
culture in the part of the world that
still tries to be civilized.

—MALCOLM COWLEY, 1939

The El Dorado is home to some of the most exceptional
Art Deco murals in the city. The paintings are filled with
warm tones and rich illustrations that contrast with the
modern stone towers of the exterior.

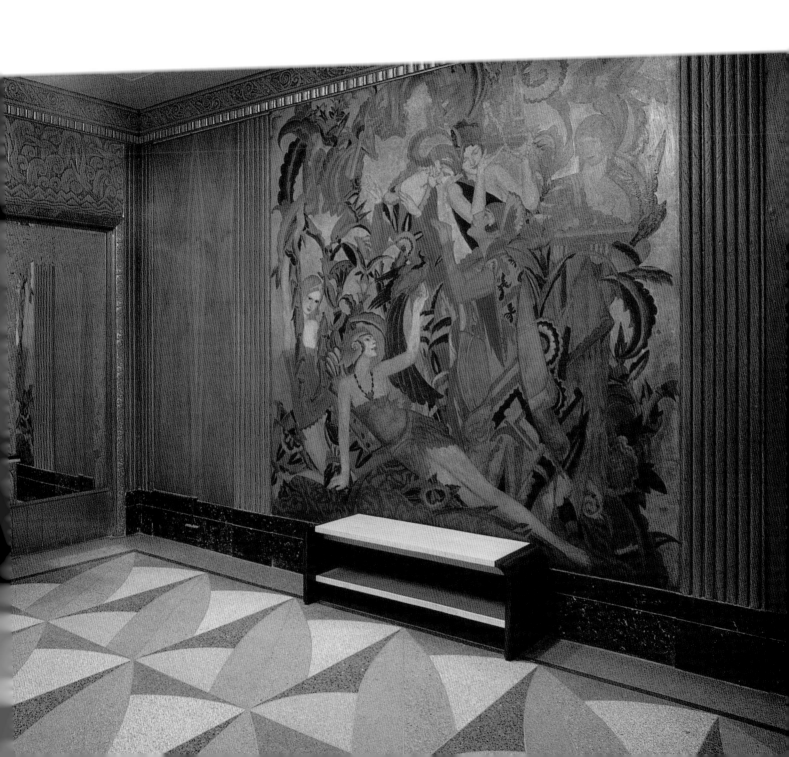

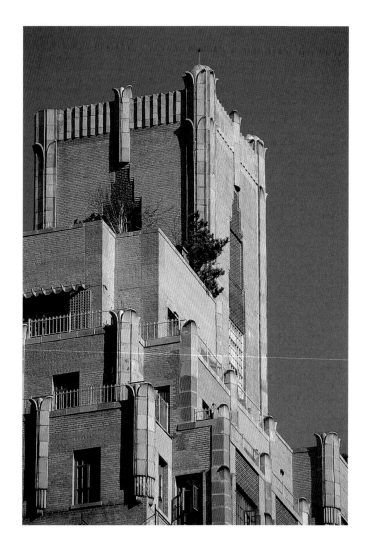

ABOVE: Other examples of Art Deco architecture on the upper West Side can be found at 241 Central Park West. The architectural firm of Schwartz & Gross designed this 1931 apartment building, as well as 55 Central Park West.

OPPOSITE: Completed in 1931, the Ardsley is at 320 Central Park West. Designed by Emery Roth, who created the El Dorado, the building features strong bands of black brick that rise up its facade and meet with the geometric patterns on the upper floors. The exterior is highlighted by a zigzag stone frieze with a four-color inlay at its base.

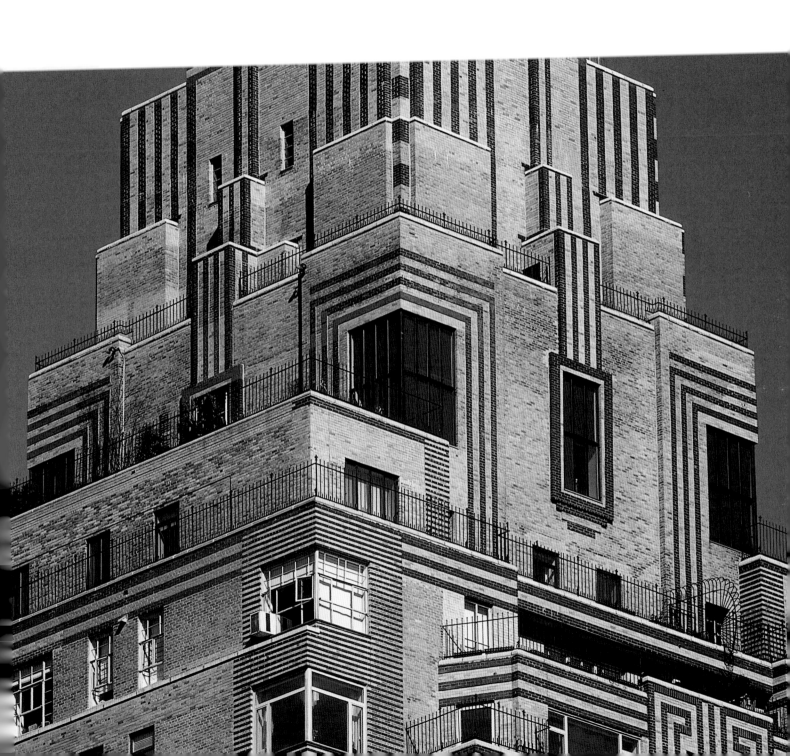

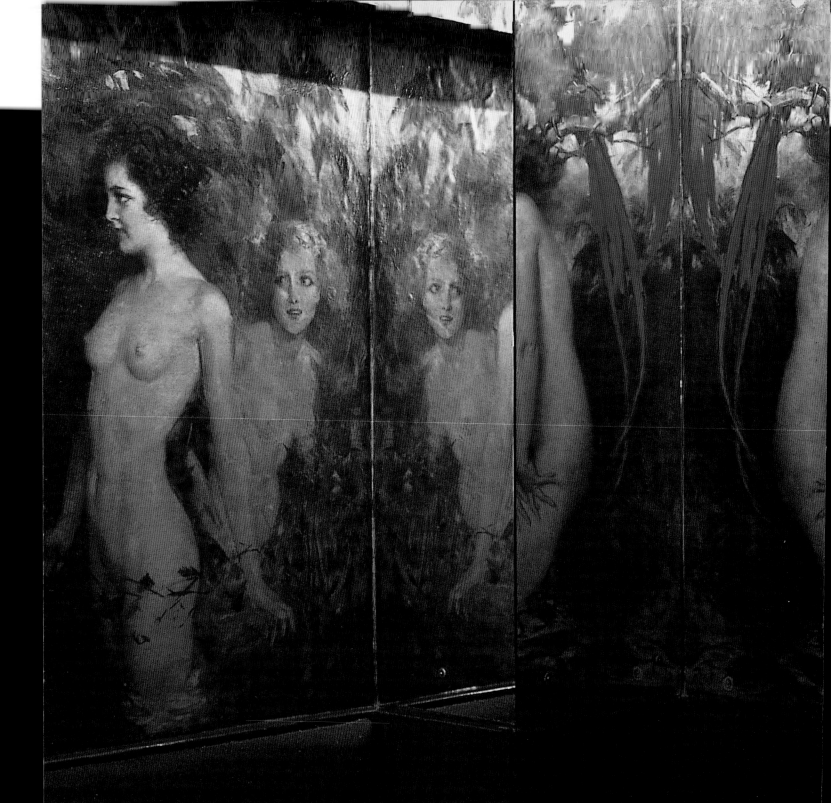

It don't mean a thing if it ain't got that swing

(doo wah, doo wah,

doo wah, doo wah,

doo wah, doo wah,

doo wah, doo wah)

It don't mean a thing, all you got to do is sing...

It makes no diff'rence if it's sweet or hot,

Just give that rhythm, ev'rything you got,

Oh, it don't mean a thing, if it ain't got that swing,

(doo wah, doo wah,

doo wah, doo wah,

doo wah, doo wah,

doo wah, doo wah)

It don't mean a thing if it ain't got that swing!

—DUKE ELLINGTON, IRVING MILLS, 1932

Part of the Hotel des Artistes at 1 West 67th Street, the Café des Artistes was designed for its residents because there were no kitchens provided in the apartments. A home for such artists as Marcel Duchamp, Norman Rockwell, Isadora Duncan, and Rudolph Valentino, the café features a mural painted in 1933 by one of the building's tenants, Howard Chandler Christy. Still thought of as one of New York's premier restaurants for romantic dining, this extravagant mural with deep colors and exotic subjects sets the mood for the entire café.

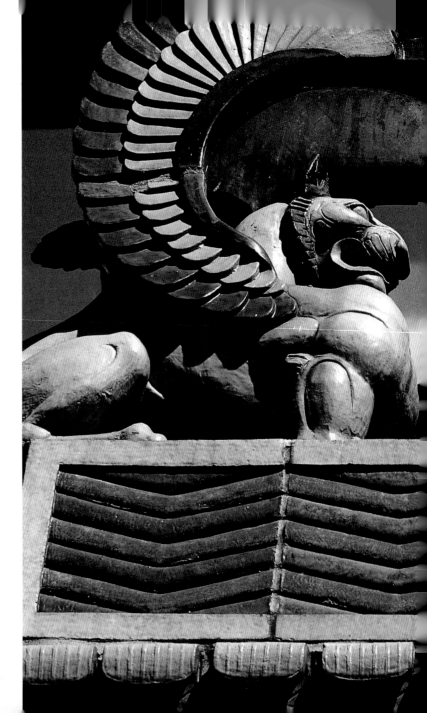

It was a cruel city, but it was a lovely one, a savage city, yet it had such tenderness, a bitter, harsh and violent catacomb of stone and steel and tunneled rock, slashed savagely with light, and roaring, fighting a constant ceaseless warfare of men and machinery; and yet it was so sweetly and so delicately pulsed, as full of warmth, of passion, and of love, as it was full of hate.

—THOMAS WOLFE, 1937

128

RIGHT AND OVERLEAF: Built in 1927 by successful movie palace designer Thomas W. Lamb, the Pythian Temple demonstrates Art Deco's reputation for dramatic flair. Intended for the Knights of Pythias and located at 135 West 70th Street, it is richly embellished with glazed terra-cotta winged lions, pharaonic figures, and blue polychrome columns.

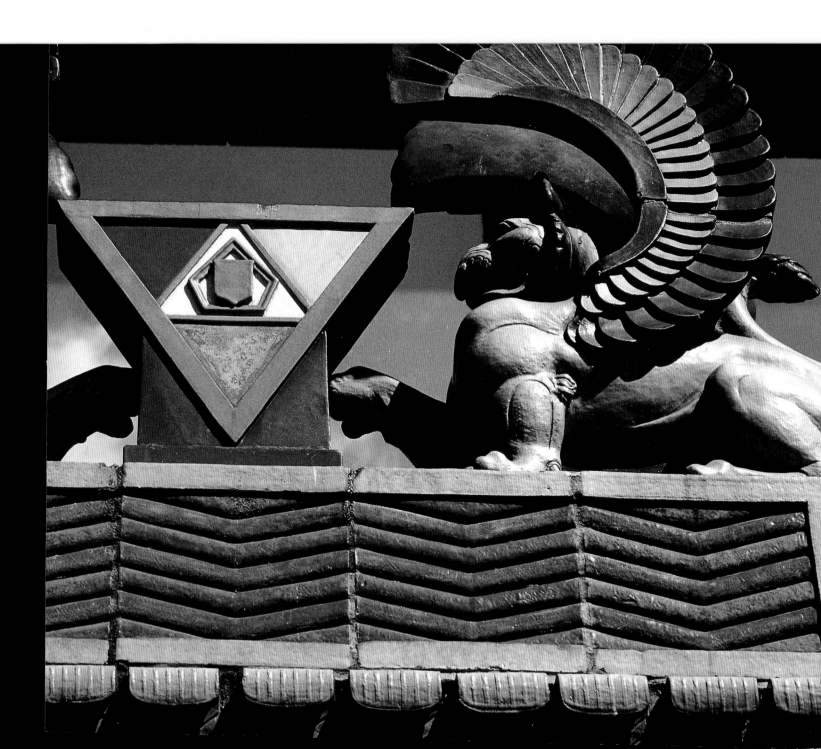

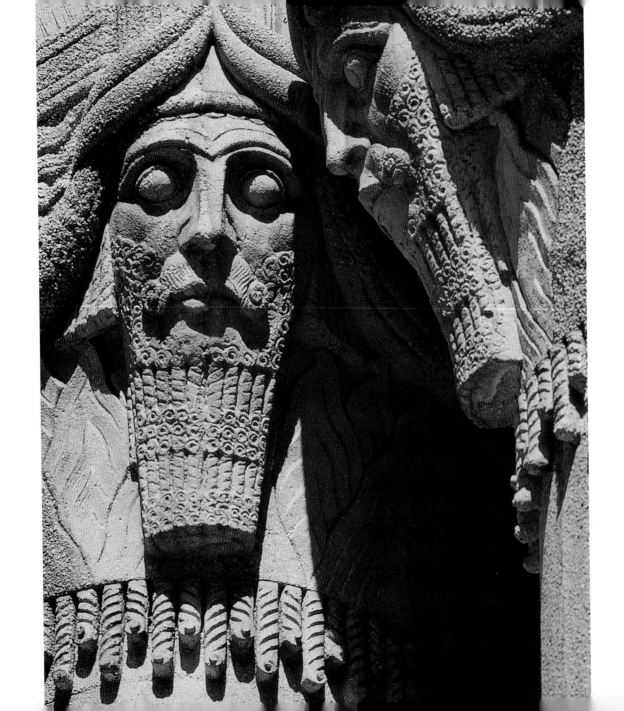

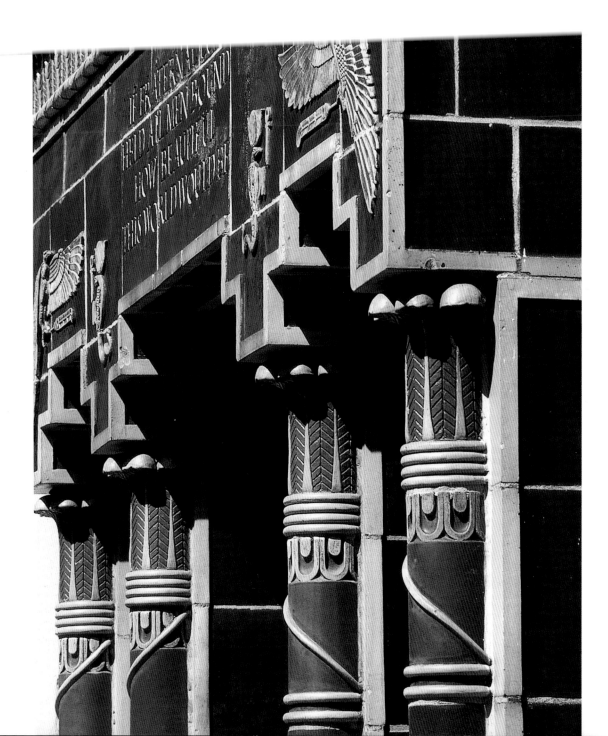

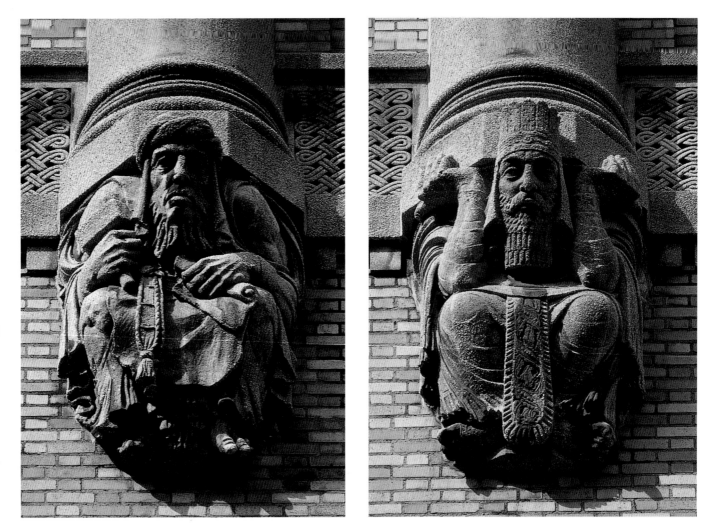

ABOVE: King Solomon's Temple was the inspiration for the Masonic Order's Level Club at 253 West 73rd Street. Designed by Clinton & Russell, the temple took some elements directly from the Jerusalem Temple, including these statues sitting under pillars. Hiram Abiff, who planned the Temple, is depicted on the left; on the right is King Solomon, who created the Temple and enforced God's strength.

OPPOSITE: Helmle, Corbett & Harrison designed the Master Building at 310–312 Riverside Drive in 1929. The building features elements such as setbacks and contrasting coloring that were distinctive to the Art Deco period.

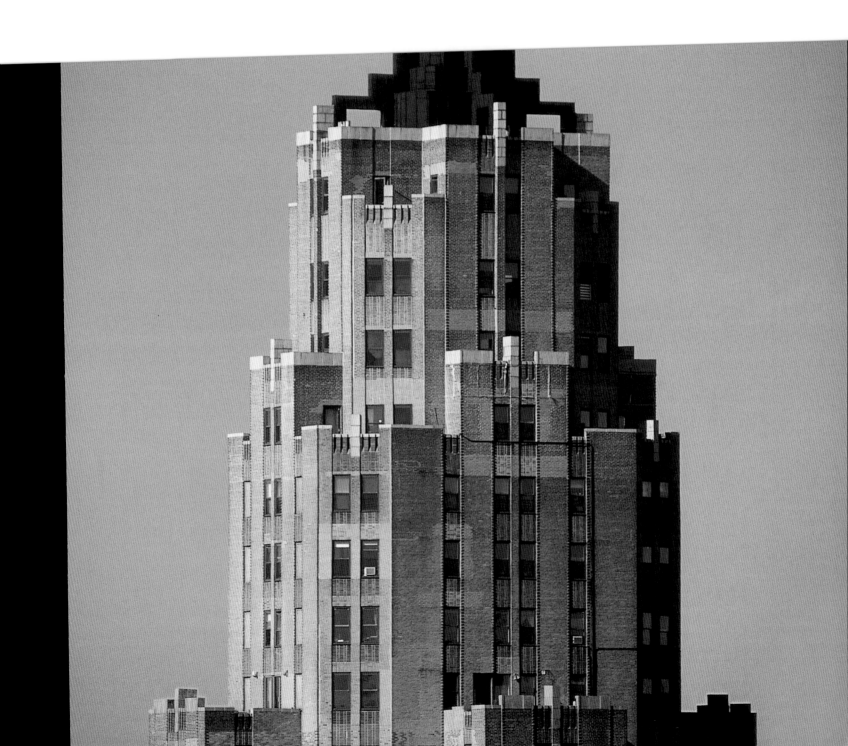

As I walk up Broadway, the people that brush past me seem always hastening toward a destination they never reach. Their motions are eager, as if they said, "We are on our way, we shall arrive in a moment." They keep up the pace—they almost run. Each on his quest intent, in endless procession they pass, tragic, grotesque, gay, they all sweep onward like rain falling upon leaves. I wonder where they are going. I puzzle my brain; but the mystery is never solved. Will they at last come somewhere? Will anybody be waiting for them? The march never ceases. Their feet have worn the pavements unevenly. I wish I knew where they are going.

—HELEN KELLER, 1929

Originally named Midtown, the Metro Theater at 2626 Broadway is perhaps most famous for its circular emblem, which shows two figures with comedy and tragedy masks. Built by Boak & Paris in 1933, its salmon-and-black background and red wave accent make it an Art Deco treasure.

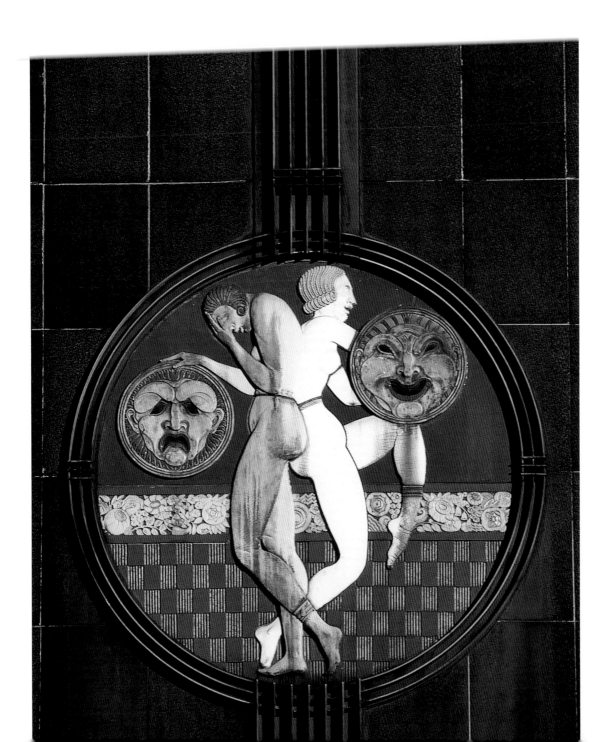

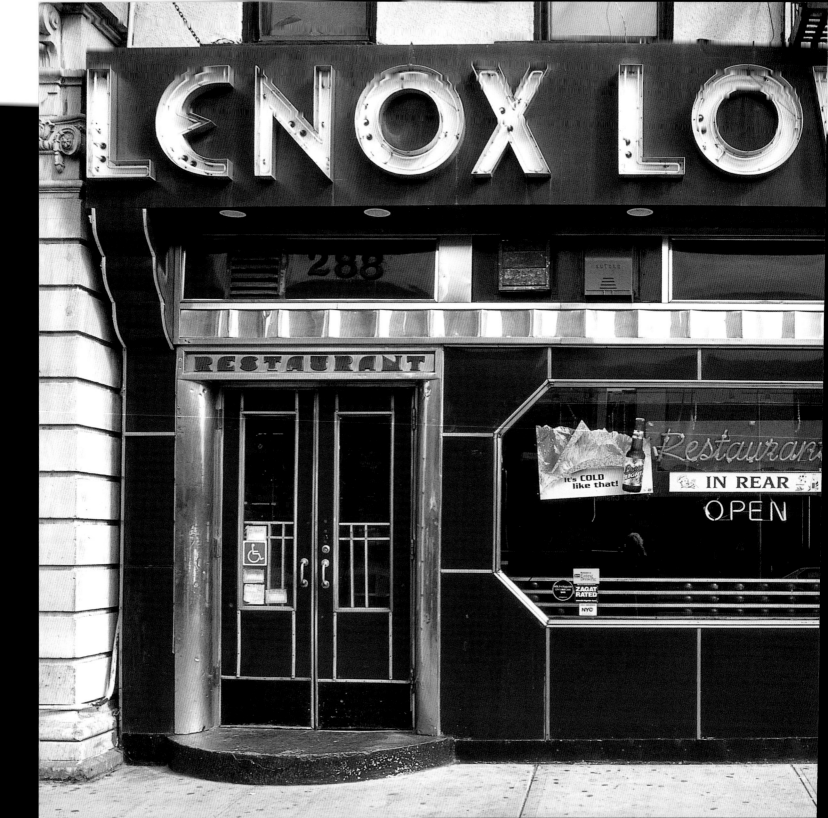

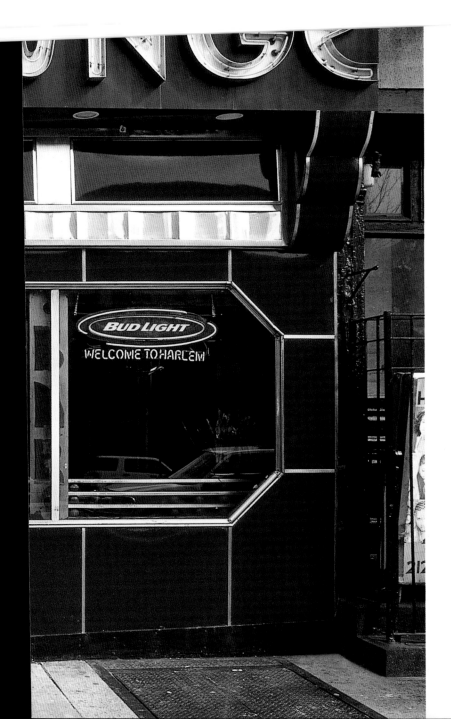

Droning a drowsy syncopated tune,
Rocking back and forth to a mellow croon,
 I heard a Negro play.
Down on Lenox Avenue the other night
By the pale dull pallor of an old gas light
 He did a lazy sway...
 He did a lazy sway...
To the tune o' those Weary Blues.

—LANGSTON HUGHES, 1926

137

Opened in 1939, this newly renovated jazz club at
288 Lenox Avenue was once *the* place in Harlem to
listen to Billie Holiday, Miles Davis, and John
Coltrane. Today the Lenox Lounge is still a great
spot to take in the unquestionably stylish Art Deco
look and to enjoy great jazz performances in the
extravagantly decorated Zebra Room.

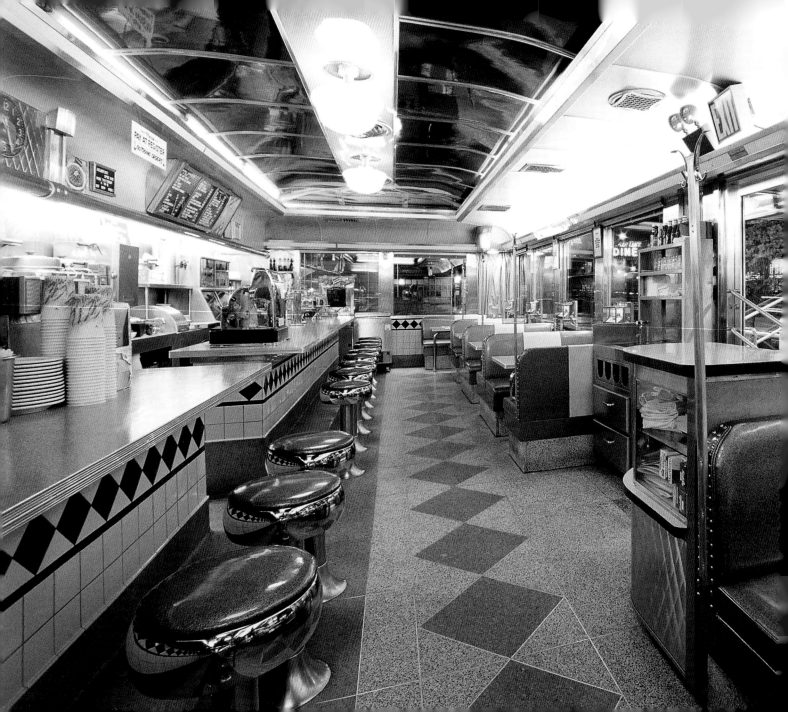

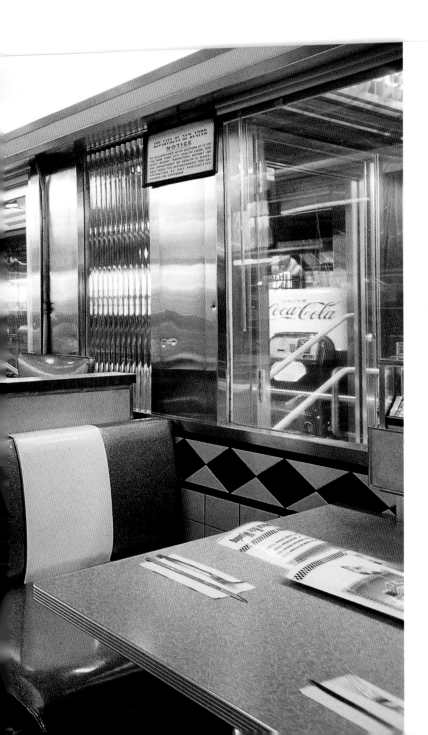

The City of New York is like an enormous citadel, a modern Carcasonne. Walking between the magnificent skyscrapers one feels the presence on the fringe of a howling, raging mob, a mob with empty bellies, a mob unshaven and in rags.

—HENRY MILLER, 1939

139

The Airline Diner, now called Jackson Hole, is a triumph of late, streamlined moderne Art Deco style. Complete with quilted metalwork, neon signs, and a terrazzo floor detailed with geometric patterns, it's located near LaGuardia Airport on Astoria Boulevard and 70th Street in Queens. Built in 1954 by the Mountain View Dining Car Company, the stainless-steel diner was featured in Martin Scorsese's film *GoodFellas*.

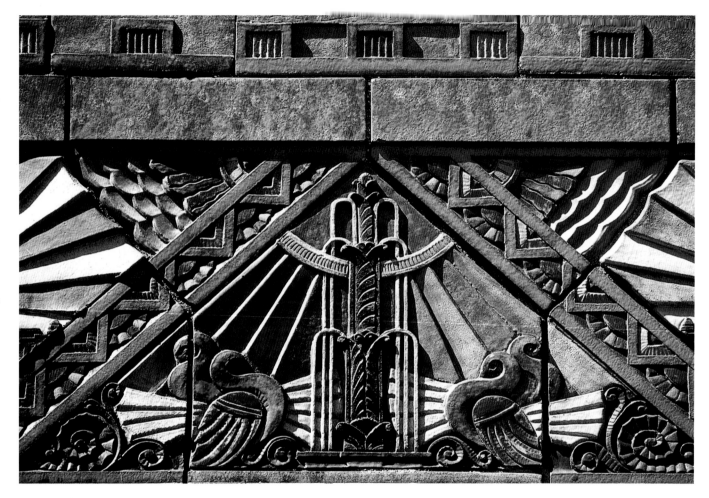

The Park Plaza Apartments, at 1005 Jerome Avenue, was the first Art Deco
building in the Bronx. Designed by Horace Ginsberg and Marvin Fine in 1929,
the terra-cotta designs show sun-worshiped buildings and fountains surrounded
by tropical birds, a sight not often found in New York.

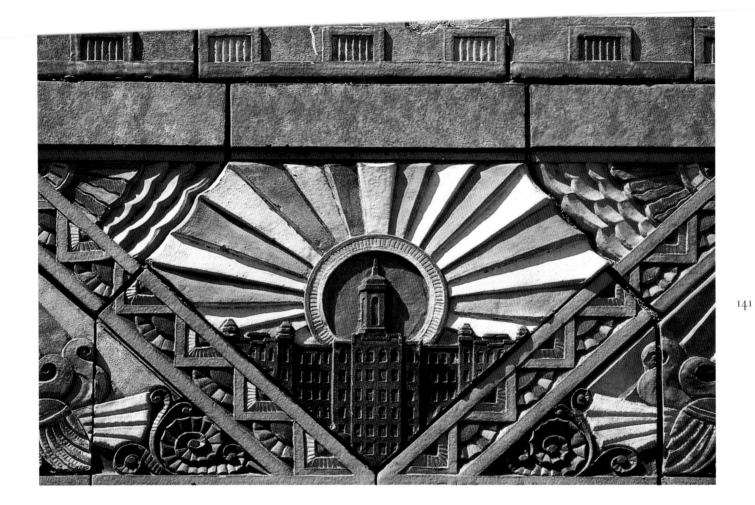

New York is a stone garden. Stone sends up stems of varying height . . . a jungle where cathedrals and Greek temples balance on stilts.

—JEAN COCTEAU

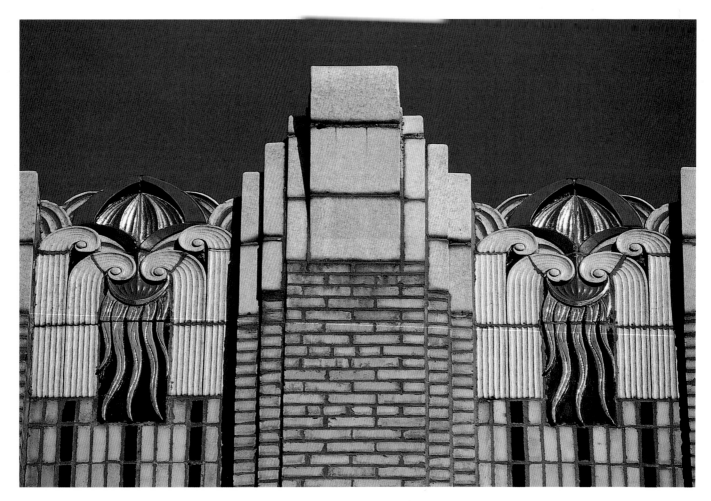

On the North Shore of Staten Island, such actors as Paul Newman, Joan
Woodward, and Martin Sheen called the Ambassador Apartments at 30 Daniel Low
Terrace home. Built in 1932, the building has a distinguished list of past tenants
and a marvelous display of Art Deco ornamentation.

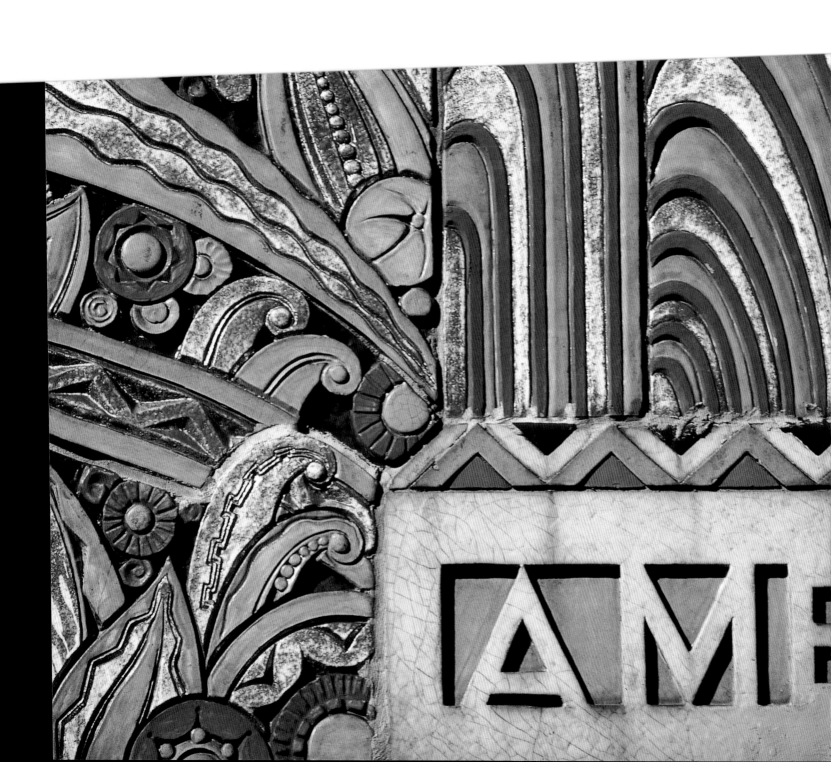

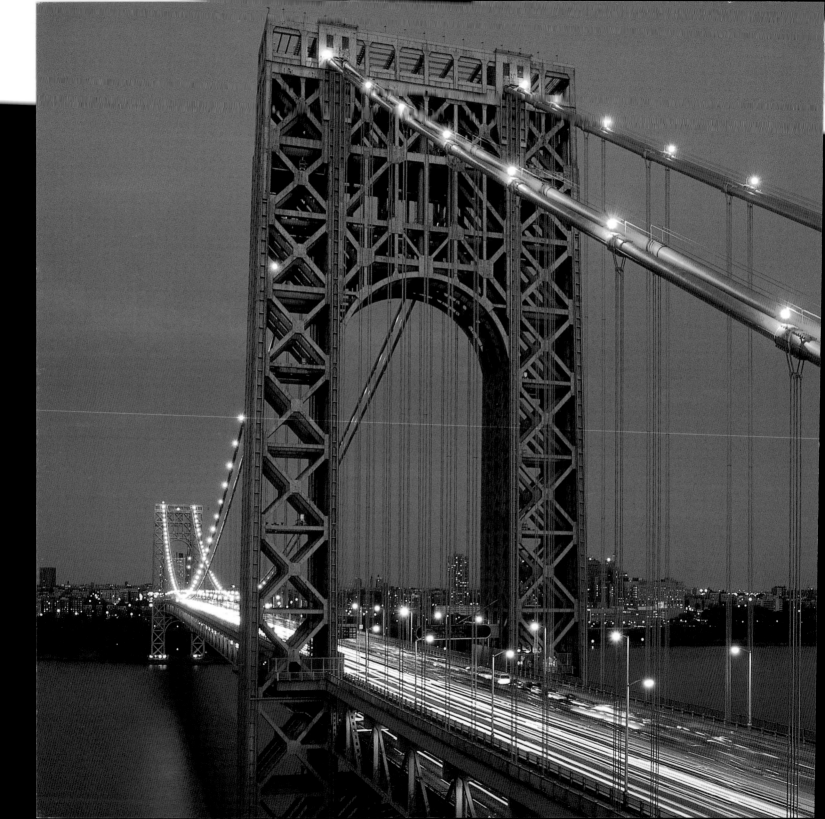

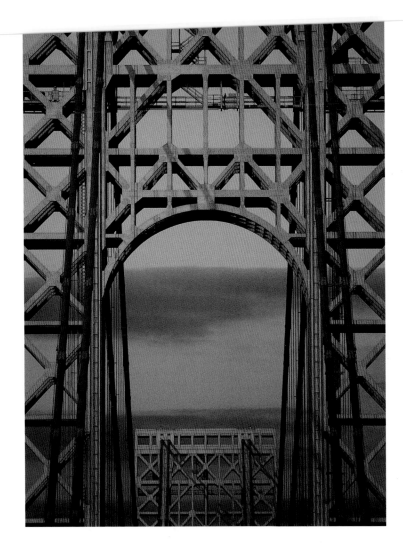

Completed in 1931, the George Washington Bridge connected New Jersey and upper Manhattan over the Hudson River. As the longest suspension bridge of its time, the GW Bridge also created a striking visual aesthetic, thanks to the exposed, functionalist towers of engineer Othmar Ammann.

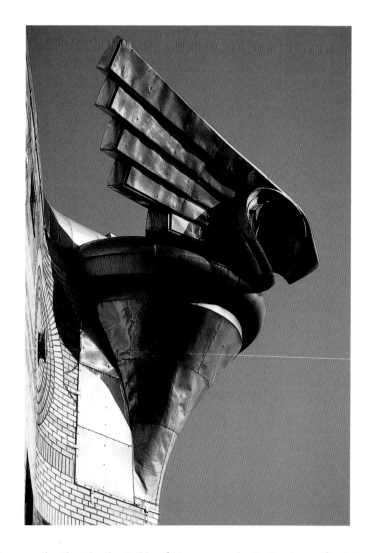

ABOVE: In honor of its namesake, the Chrysler Building features gargoyles in the shape of radiator caps, hood ornaments, and metal hubcaps that decorate the setbacks and shaft of the structure—all symbols of the great American automobile.

OPPOSITE: The most recognizable feature of the Chrysler Building, completed in 1930, is its seven-story steeple, cut with whimsical crescent-shaped steps and enhanced by a classic Art Deco sunburst motif. When competition increased to make the world's tallest building, Architect William Van Alen created the vertex of the spire inside the Chrysler's upper floors, revealing it during the last 90 minutes of the project. This stunt won the building the title of world's tallest—until the Empire State Building was completed a year later.

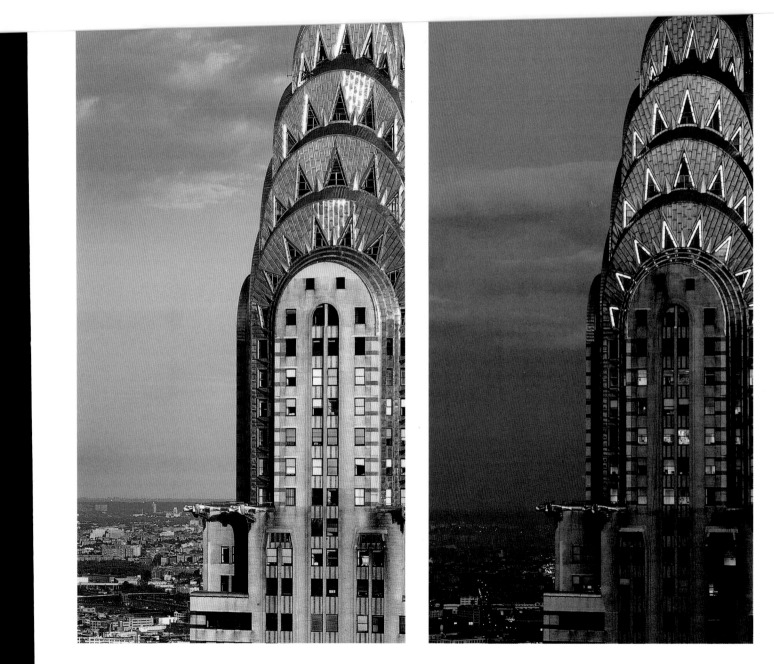

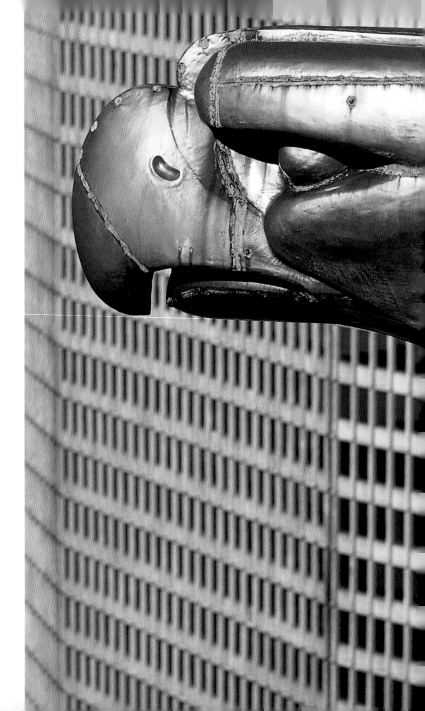

I regard it as a curiosity; I don't let myself get caught in the wheels.

—LUDWIG BEMELMANS

Jutting out below Chrysler's steeple on the sixty-first floor are these stylized eagles.

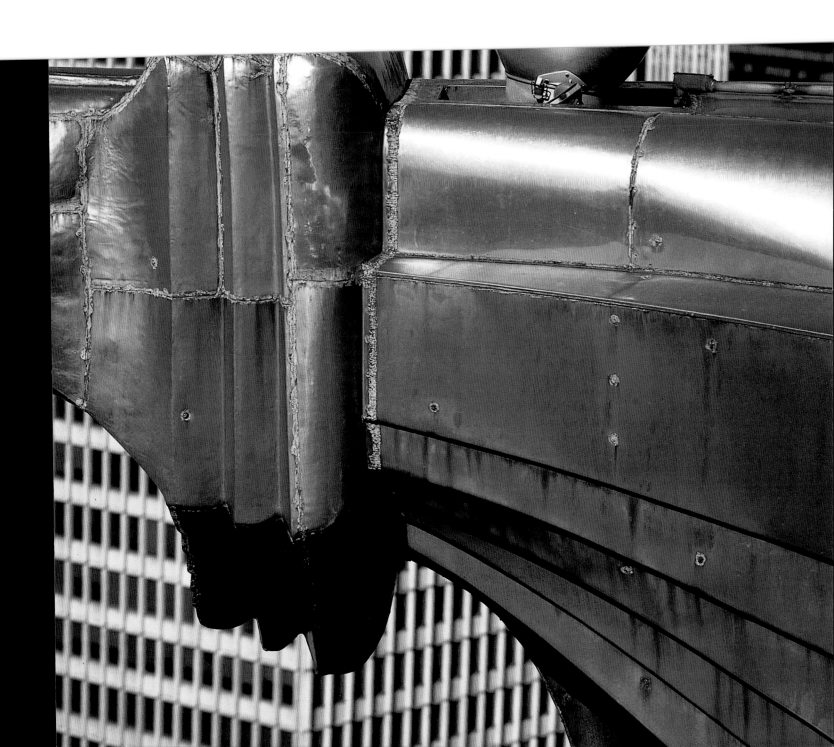

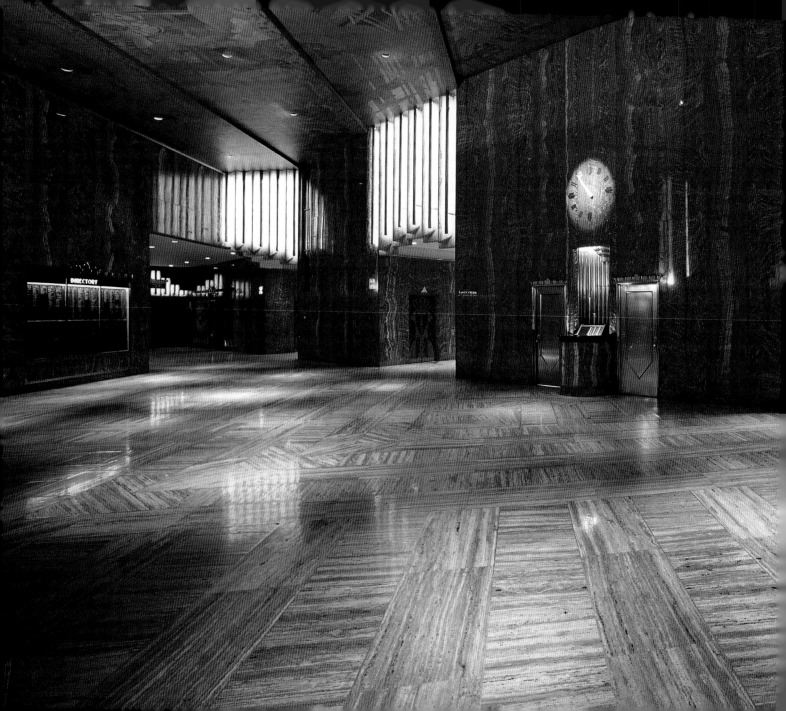

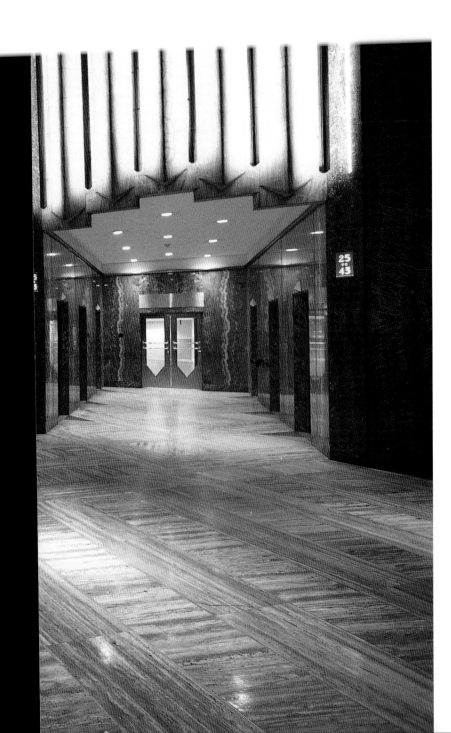

[N]ew York City is] the sensual mysticism of entire vertical being.

—E.E. CUMMINGS, c. 1920s

The lobby of the Chrysler Building features stunning red Moroccan walls and sienna-colored marble floors, all accented with amber onyx and blue marble trim. The marble work, in combination with the exalted ceiling, further exemplifies the opulence of the Art Deco period.

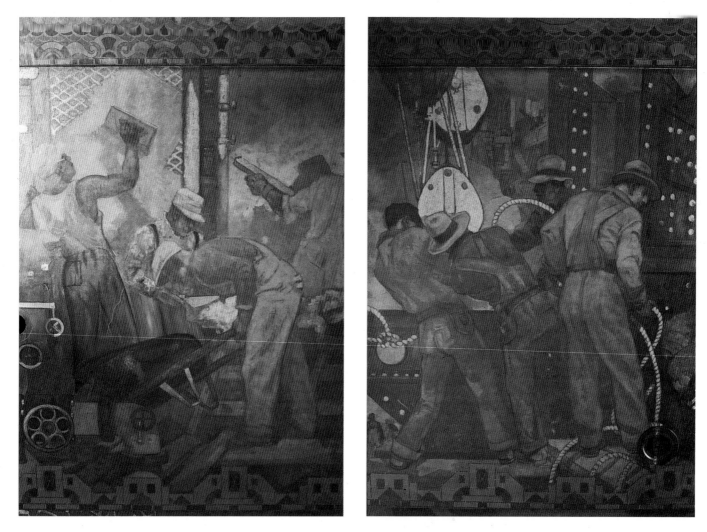

ABOVE: An impressively large mural created by Edward Trumbull entitled, *Energy, Result, Workmanship and Transportation*. The painting celebrates modern-day progress through its vibrant images of planes, construction, and the Chrysler Building itself.

OPPOSITE: The elevators inside the Chrysler demonstrate the exotic Egyptian influence on Art Deco designs. Lined with wood from all over the world, the building's thirty-two elevators were designed by Van Alen himself, who was said to have spent a month reveling in the project.

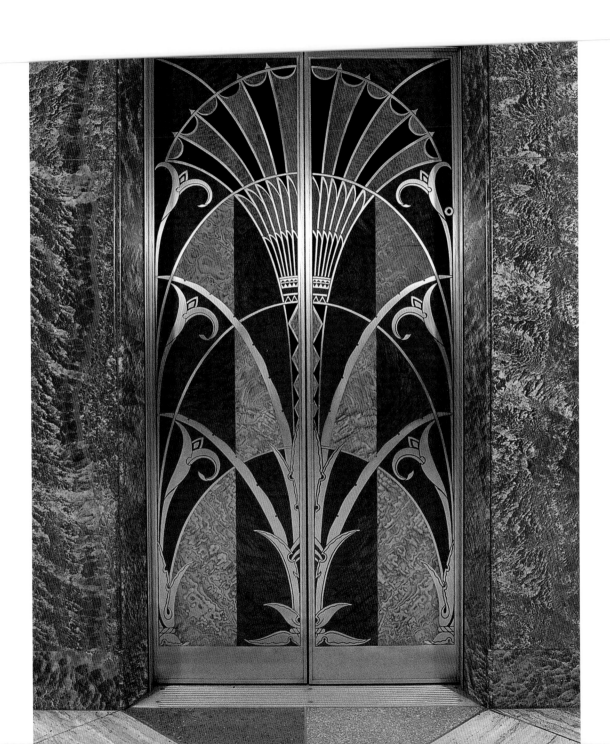

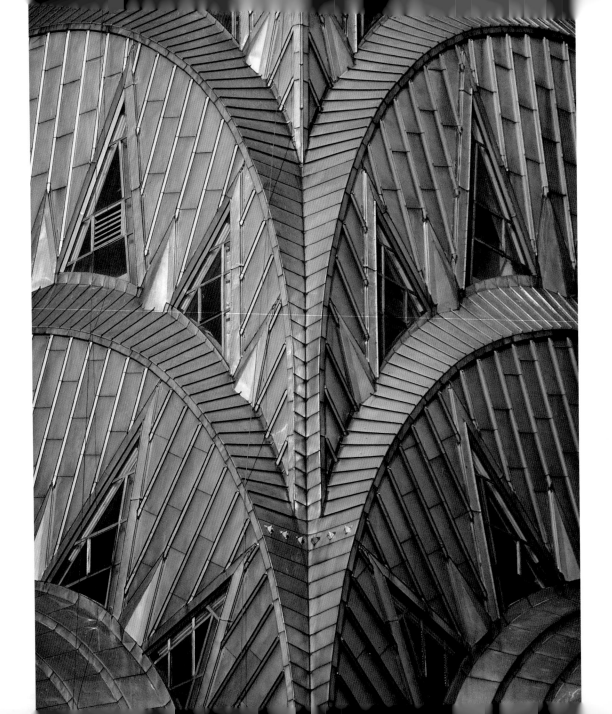

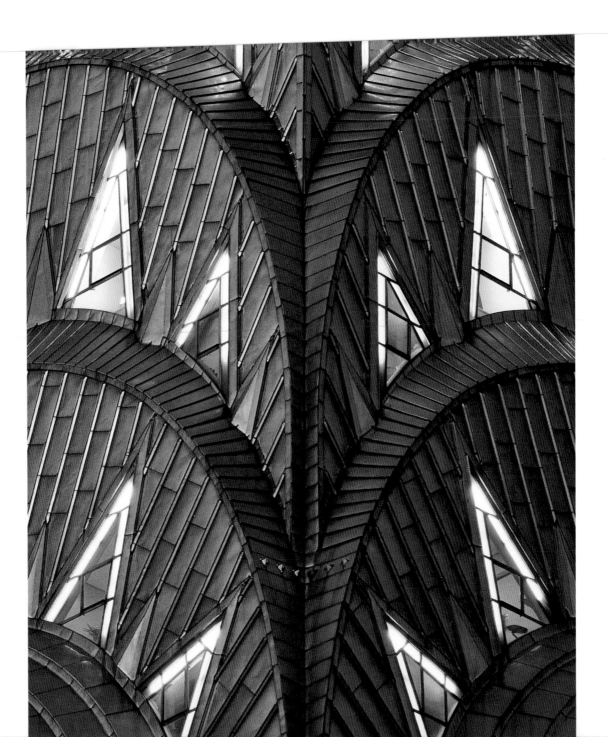

You're the top! You're a Ritz hot toddy.

You're the top! You're a Brewster body.

You're the boats that glide on the sleepy Zuider Zee,

You're a Nathan Panning, You're Bishop Manning,

You're broccoli.

You're a prize, You're a night at Coney,

You're the eyes of Irene Bordoni,

I'm a broken doll, a fol-de-rol, a blop,

But if, Baby, I'm the bottom,

You're the top.

—COLE PORTER, 1934

PRECEDING PAGES: Only the small triangular windows on the Chrysler Building—seen here during the day and at dusk—interrupt the flow of its overlapping silver scales. The material used on the steeple, Nirosta, is a mixture of chrome, steel, and nickel. The Chrysler Building was the first to use Nirosta on the exterior of a building.

OPPOSITE: Van Alen's Chrysler Building effortlessly captures all the elements of New York's Art Deco period. Beginning with a foundation of stylized black, white, and gray bricks, the Chrysler illustrates romance, ingenuity, and modernity through a richly colored marble lobby, a spectacular use of a new material, architectural tributes to the Chrysler company, whimsical curves, and, above all, breathtaking verticality.

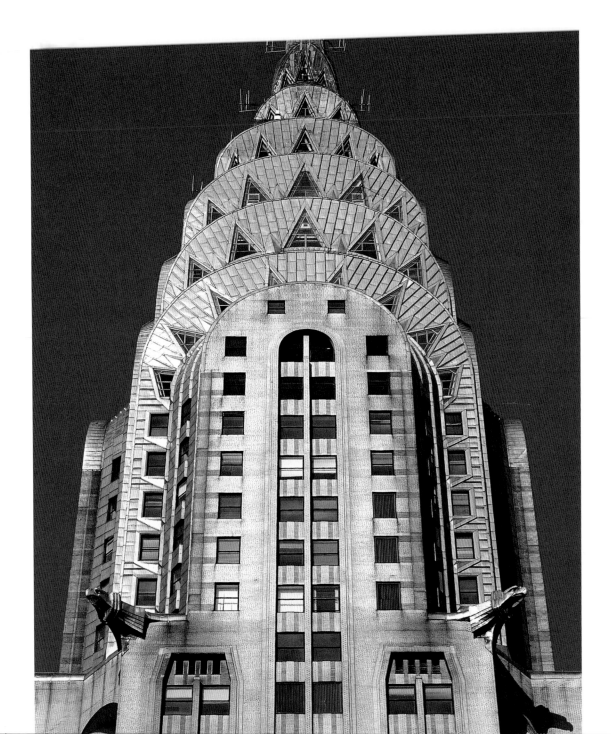

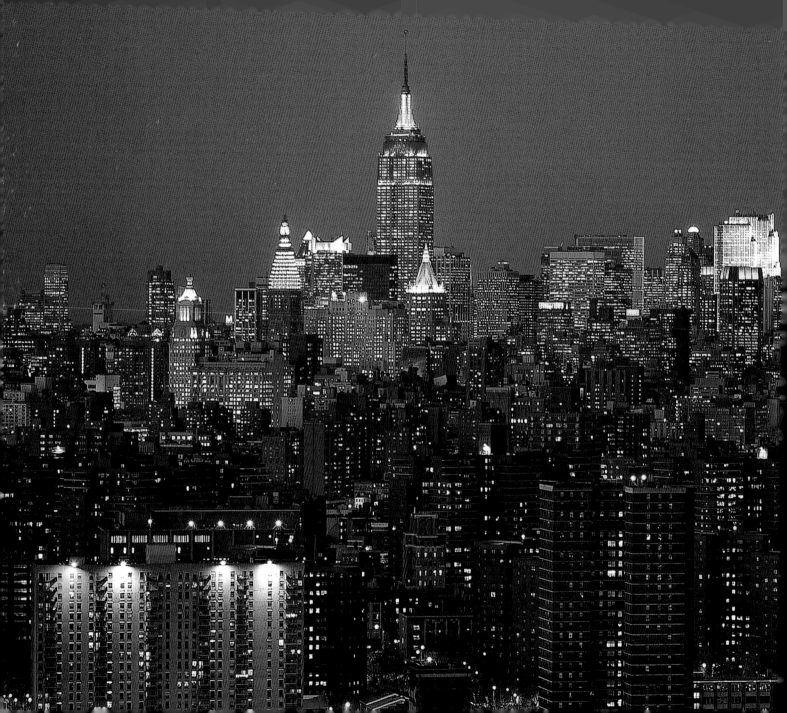

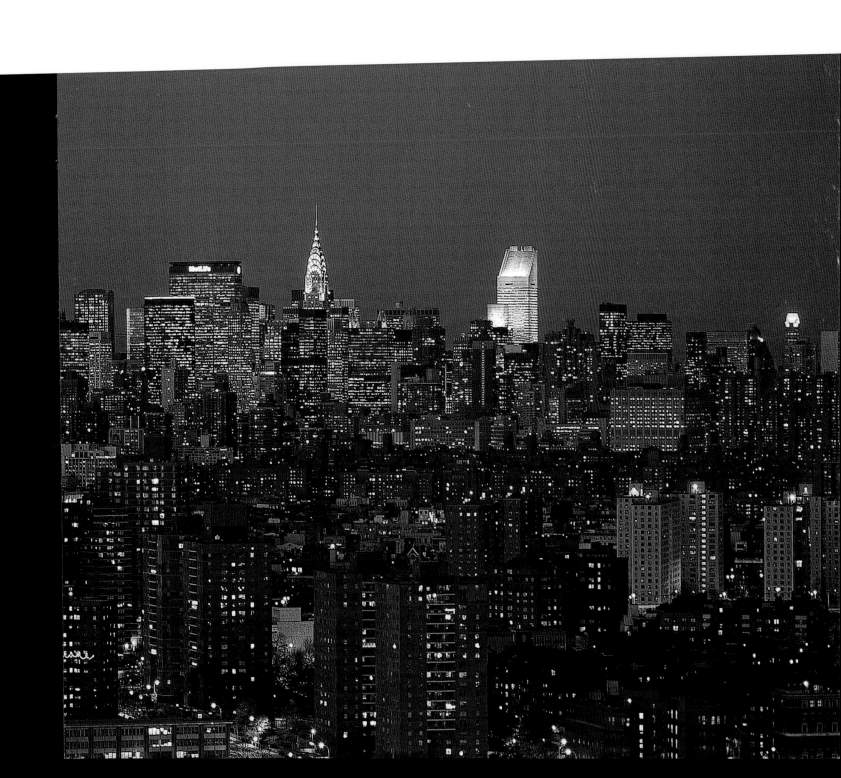

Published by Scriptum Editions
An imprint of Co&Bear Productions (UK) Ltd
565 Fulham Road, London, SW6 1ES
Originally published in the USA by Welcome Books

Publishers: Beatrice Vincenzini & Francesco Venturi
Designer: Gregory Wakabayashi
Project Director: Natasha Tabori Fried
Captions: Maren Elizabeth Gregerson
Text Research: Deidra Garcia

Printed in China

First Edition
10 9 8 7 6 5 4 3 2 1

ISBN 1 902 686 49 7